REMEMBERING NEW YORK'S
NORTH COUNTRY

REMEMBERING NEW YORK'S

NORTH COUNTRY

Tales *of* Times Gone By

DAVE SHAMPINE

Nancy —
my good buddy at JCC
Good to still have you as a friend
My Best wishes

Dave Shampine

Charleston — London

THE
History
PRESS

Published by The History Press
Charleston, SC 29403
www.historypress.net

First published 2009
Second printing 2011

Manufactured in the United States

ISBN 978.1.59629.790.6

Library of Congress Cataloging-in-Publication Data

Shampine, Dave.
Remembering New York's North Country : tales of times gone by / Dave Shampine.
p. cm.
ISBN 978-1-59629-790-6
1. Watertown (N.Y.)--History--Anecdotes. I. Title.
F129.W3S53 2009
974.7'57--dc22
2009023235

CONTENTS

FOREWORD

The slogan for the *Watertown Daily Times* is "News for today, history for tomorrow." And no reporter has embraced that concept more than Dave Shampine.

As a reporter here for more than thirty-five years, Dave has been on the front lines, telling our community's stories that have either inspired or shocked. His feature stories have been filled with hope and joy; his crime stories have revealed utter depravity and indifference. No matter the story, Dave's goal has been to give our readers the news of the day, whether it is good or ugly.

But by using the vast archives of our paper, Dave has also ensured that today's generation of readers has some sense of where our community has come from. In these stories, we are reminded that technology and lifestyles can change but the human condition remains the same.

Prominent people are accused of serious crimes; children find unexploded ordnance with tragic results; the movie *Titanic* mirrors the life of a woman who lived here—the stories Dave has found are more than just headlines from years ago. Through careful research, Dave shows our readers how the ways in which decisions were made, money was spent and people were treated have ramifications even today.

These are stories that needed to be told more than once. And Dave Shampine has been here to do just that.

Bob Gorman
Managing Editor
Watertown Daily Times

ACKNOWLEDGEMENTS

I would like to acknowledge the following people for their involvement in editing and paginating my monthly column: Mary Kaskan, Sunday editor; Judy Jacobs, Currents editor; copy editors Mary Lu White and Cathie Egan; and pre-press technicians Kathy Tufo and Danna Moles. Also, pre-press technician Gary Bartlett and Michael Loftus, production systems support technician, processed photographs for this book.

MISSING PIECES
OF A PUZZLE

A mystery that had baffled Jefferson County officials for two years, and caused a few red faces along the way, was about to be solved. Or so it seemed.

It was a mild Monday in mid-January 1913, with not an inch of snow to hide the burial spot. Clara Hicks of Glen Park and her father, John Dockstater, stood in anticipation in the Chaumont Cemetery while Jacob J. Dillenbeck, the cemetery sexton, carried out the exhumation of a man's body. When the remains were finally revealed, Mrs. Hicks was convinced. The second toe on the right foot was missing. The corpse, she determined, was that of her missing husband, Leonard Hicks.

Mrs. Hicks's pronouncement on January 20, 1913, would be proven wrong. But this was nothing new for this particular John Doe. The eight inches of snow that fell that night only served to bury deeper the puzzle about the man who was found dead in a tree on William Arnold's farmland, Whitefish Point (now called Dutch Harbor), at Three Mile Point on Chaumont Bay.

The John Doe mystery had proven to be a thorn in the sides of the county coroner, the district attorney and a Watertown police detective. To the sheriff, it was a compounding embarrassment.

Sheriff John H. Bogart, a town of Alexandria native, farmer, feed store owner and town supervisor, had taken office in 1909. A year later, in August, the county's new $90,000 jail at Coffeen and Massey Streets in Watertown was entrusted to his care.

The county was proud of its jail; that is, until Sunday night, July 9, 1911, when five of the facility's inmates staged a daring escape to ruin any plans for a first-anniversary party.

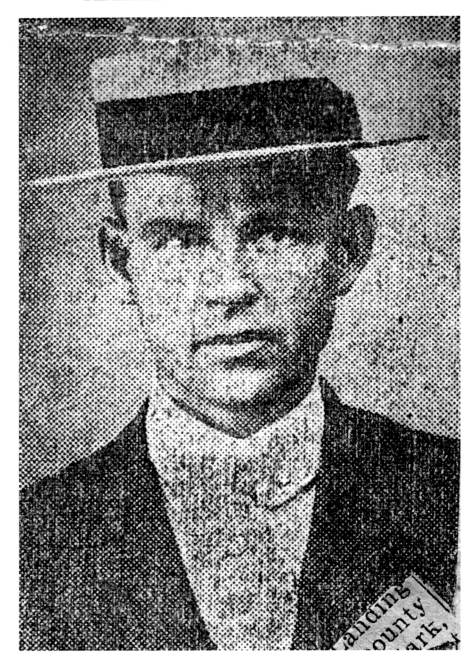

Harry Newton, alias H.C. Williams. *Courtesy of the* Watertown Daily Times.

Tales of "Times Gone By"

Returning from a carriage ride, Sheriff Bogart discovered shortly after 9:00 p.m. that inmates W.B. Sheldon (alias James F. Allen), Harry L. Newton (alias H.C. Williams), Fred Bartell, Charles Pratt and Frank E. Clark were nowhere to be found.

They had exploited the jail turnkey's carelessness, one of them would later say. The inner door of the corridor had been left open, enabling them to slip out. But another in the group boasted that he had fashioned a key that unlocked the door.

A countywide search was launched, and late the following night, the desperados were discovered on the main street of Depauville. Deputy Sheriff Spencer confronted them and succeeded in handcuffing one. A second man, Harry Newton, ran.

The deputy fired his big .38-caliber Colt Army revolver four times as Newton ran, zigzagging down the street. Next to the roadway was general store owner H.G. Jones, poised on one knee in front of the village's hotel, aiming his double-barreled shotgun.

"Shoot!" the deputy demanded.

A blast rang out, but Newton, thirty-eight, although wounded in the leg, turned the corner around the hotel and disappeared into the darkness.

Sheldon, forty-one, a burglar, was in custody, and in short order, three others were rounded up. There was Bartell, forty, an accused bigamist; Clark, thirty-five, who was facing a grand larceny charge; and Pratt, thirty-two, who had been jailed for placing his wife in a house of ill fame.

The runner, Newton, was an ex-convict who had been arrested for burglary in Watertown. He was still listed as missing late that September when, on a Sunday afternoon, two boys who were out hunting came upon a gruesome scene. The youths saw a black shoe protruding from a tree near the shore of a creek, and when they looked closer, they saw a man's body hanging from the top of the tree.

The frightened boys took flight and told some half-believers in Chaumont of their discovery. "Half of the village" started for the woods, the *Watertown Daily Times* reported, and "there was the body, hanging limply from the crotch high up, and it swayed a bit in the slight breeze."

As evening closed in, Dr. Herbert L. Smith, the coroner, arrived.

"I found quite a crowd of people under the tree in question," he wrote in his report.

At his request, one of the villagers, Roy Giles, used a rope to lower the body. Dr. Smith's initial observation was that "this is a foreigner, probably Hungarian or Pole."

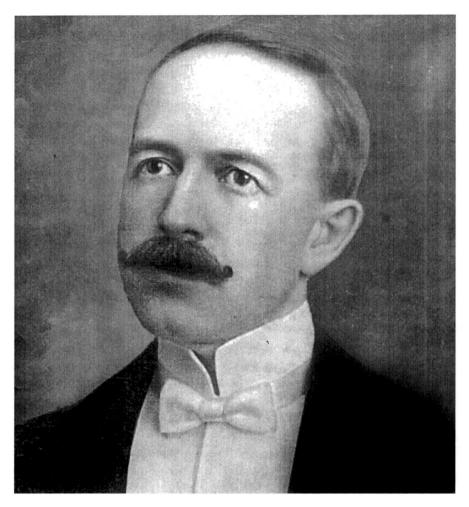

Dr. Herbert Smith. *Courtesy of the Jefferson County Historical Society.*

No identifying papers were found in the mummified victim's clothing. There was an empty envelope, similar to the payroll envelopes used by the railroads. The number 261 was written on the paper, but that clue would lead nowhere.

The body had been in the tree at least two months, estimated Dr. Smith, who, at forty-eight, was in his twenty-third year of medical practice, his second as coroner. The physician, like other witnesses to the day's event, had his suspicions about the identity of the body. The corpse's slim build— about 145 to 150 pounds and five feet, nine or ten inches in height—closely

matched the physique of the missing jail escapee, Harry Newton, who was five feet, nine and a half inches tall.

The dead man's suit of clothes was different from what Newton was wearing on his day of flight, but wouldn't a fugitive change his clothes to avoid detection?

Sheriff Bogart and his son-in-law, Clark Schell, the embarrassed jail turnkey, took a look at the body. They concurred: it was Newton. One of the captured escapees, Sheldon, was asked to confirm their determination.

"I am almost sure [that it is Newton's body]," Sheldon said after examining the mouth. "Harry had an exceptionally fine set of teeth, free from fillings. His head was almost exactly the same shape as the head of the corpse."

The one identifying feature that Sheldon hoped to find was not there, due to decomposition. "You know Harry was an electrician, and his fingers had thickened so that they were much different from those of the average man," he explained.

Dr. Smith was still unconvinced and sought the opinions of Watertown police officers. Captain Edward J. Singleton, not one of Newton's favorite law officers, and Chief Gaylord L. Baxter went to the morgue in Chaumont, where the coroner had the body placed.

"We believe that it is Newton," said Chief Baxter. "We based our conclusion on the high cheek bones, one ear protruding more than the other and the scar on the chin, all these features being almost identical with those of Newton."

Dr. Smith concluded that the death was a suicide and asserted, "I am as certain as it is possible to be that the man was Newton." He noted that the dead man's hair was lighter than Newton's, but he rationalized that this was caused by constant exposure to the sun following death.

District Attorney Claude B. Alverson, in the first of his six years as county prosecutor, said he was "as certain as a man could be" that it was Newton's body, but he was not taking any chances. He said that he would still present evidence from the burglary case to the grand jury to secure an indictment against Newton, just in case the unthinkable should occur.

Sheriff Bogart and Dr. Smith sent a telegram to the police department in Pemberton Square, Massachusetts, advising that "Harry L. Newton, alias H.C. Williams, alias H.C. Spaulding," had been found dead. "Please notify the mother or brother of Newton, residing at Fields Corners, a suburb of Boston, as to what disposition to make of the remains."

Following burial in a pauper's grave at Chaumont, a woman placed flowers at the unmarked site for "the man who had gone wrong."

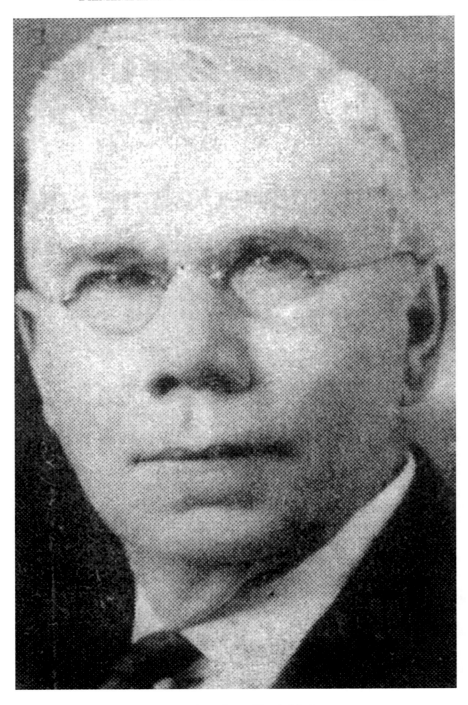

Sheriff John Bogart. *Courtesy of the Jefferson County Historical Society.*

The case was closed to everybody's satisfaction until nearly four weeks later, on October 17, 1911. A telegram to Sheriff Bogart disclosed that Harry L. Newton, fugitive from Watertown, had been captured in Erie, Pennsylvania.

Headlines screamed: "Officials Puzzled over Man in Tree" and "Who Was the Man Buried?"

Dr. Smith was now wavering over his suicide ruling. He began talking as if he suspected that the body had been placed in the tree. It would have taken at least two men to accomplish the ghastly deed, he said, "and they had their hands full."

If that were the case, had John Doe been a victim of murder?

Chaumont undertaker R.S. Clark thought so. When he removed clothing from the body, he found "clean cut" holes in both the under and outer shirts, on both the front and back sides, suggesting that a bullet had passed through the victim's upper torso. The portion of the body corresponding to the holes in the shirts was most severely decomposed, and he noted that inflammation from a wound would cause the most rapid decomposition.

Then came word from former Watertown judge George W. Reeves, soon to be the county judge, who recalled being awakened one midsummer's night in his summer home at Independence Point, Chaumont, by two gunshots and a scream. The shots, in rapid succession, had come from the general direction of where the body was found, he thought.

The property owner, Mr. Arnold, recalled another summer incident, possibly tied to this apparent homicide. Three men, speaking little English and presumed to be either Italian or Polish, had come to the Arnold farmhouse at dusk seeking food. Mr. Arnold sold them bread and milk and then sat with them while they refreshed themselves behind his barn. They had come from New York to work on a road job, they told him, and were now looking for new work. They were lost, they said, and wanted to go to Cape Vincent. Curiously, when the trio departed, each went in a separate direction. One, wearing a black derby hat, took a direction that would have brought him to the tree.

A derby was found at the foot of the tree. The frame of John Doe was similar to that of the man in the black derby, Mr. Arnold told the authorities.

Following the possibility that the victim and his killers were European, authorities found a unique coincidence: placing a body in the branches of a tree was often the means by which murderers in Italy, Romania and Hungary disposed of their victims.

With those leads and theories compiled, Dr. Smith ruled in his inquest that the unidentified man was the victim of "murder in the first degree." But

the doctor, the sheriff and the district attorney were no closer to knowing who had been murdered. The mystery went unsolved until finally, fifteen months later, Clara Hicks gave hope that she had the answer.

Mrs. Hicks, employed at Hungerford & Holbrook Co. in Watertown, asked Dr. Smith in 1912 for permission to have Chaumont's John Doe exhumed. She told him that she believed the dead man was her husband, Leonard, who was thirty-one when he disappeared on May 11, 1911. On that day, her husband, whom she described as a heavy drinker, had gone to Evans Mills, where they were storing some furniture.

The coroner initially declined, sending the woman to Sheriff Bogart to view the clothing found on John Doe. From the sheriff, she learned that the clothing had been lost.

After the undertaker, Mr. Clark, agreed that the body might have been that of Leonard Hicks, Dr. Smith granted the woman's request. He set a condition: if she could not identify the body, she would pay the cost of opening the grave. But if she determined it to be her husband, Dr. Smith agreed that the county would be billed.

Seeing a toe missing from the skeleton's right foot, Mrs. Hicks declared not only that it was her husband but also that he had been murdered. She was unable to explain her latter conviction, since she said her husband had no money and no enemies.

Also viewing the body that day was Dr. Oliver J. LaFontaine of Chaumont. A missing limb was the only possible means of making an identification at this stage of decomposition, he said, but he was doubtful. The toe could simply have fallen away with decay.

Mrs. Hicks's declaration had the mystery solved for one day. Mr. and Mrs. J. Gordon, of 244 High Street, Watertown, disclosed that they had seen Leonard Hicks alive—and talked to him—during the summer of 1912 in Kingston, Ontario. A few days later, Mr. Hicks was found in Syracuse.

His wife sued for divorce.

The question of "who was the man buried" was never answered. Adding to this person's anonymity is the fact that today, the whereabouts of his unmarked burial site are unknown.

Dr. Smith remained the coroner until the end of 1915. A native of South Rutland, he continued his Watertown medical practice beyond his ninetieth birthday and died in 1957 at age ninety-three.

Detective Singleton, who made an unsuccessful bid to be elected sheriff in 1911, became Chief Singleton two years later, succeeding Chief Baxter upon his death.

Sheriff Bogart did not seek reelection in November 1911. He died in August 1929.

District Attorney Alverson went on to become county judge, winning election in 1918. He advanced to state Supreme Court judge in 1921 but died after a three-week illness on December 23, 1922. He was forty-four.

Mr. Arnold met an accidental death on the Chaumont–Three Mile Bay Road that crossed his property. The sixty-one-year-old farmer was walking a team of horses back to his barn on the night of November 18, 1930, when he was struck by a car, the driver having been blinded by another motorist's headlights.

Harry Newton was convicted of escape and was sentenced in December 1911 to three and a half years in prison. When last heard from in April 1916, he was accused of planting a bomb in the offices of J.P. Morgan & Co. in New York City. The charge was dropped when it was determined that he possessed an empty shell case, which was allegedly stolen from a munitions plant in St. Catherines, Ontario. Federal officers tried to extradite him to Canada until investigation revealed that "the larceny charge was baseless," according to a newspaper report. He thereafter announced, "I am going back [to Canada] of my own free will...I have nothing to fear in Canada."

At the time of his arrest in New York, he was found to possess home-fashioned keys.

A NORTHERN NEW YORK WOMAN SURVIVED THE *TITANIC*

You're going to make lots of babies and you're going to watch them grow."
So said a dying Jack Dawson to Rose Bukater in the movie *Titanic*.

For a real teenager who survived the sinking of the *Titanic*—and who years later lived in Lowville and Gouverneur—those words came true. Laura Mary Cribb, a third-class passenger like the blockbuster film's Jack Dawson, was among the 711 passengers who survived the early morning hours of April 15, 1912. If the movie had focused on her rather than the fictitious Rose and Jack, it would have shown the teen giving "one awful shriek" and losing consciousness as she watched from a lifeboat the "unsinkable" luxury liner slip beneath the frigid surface of the Atlantic Ocean.

Going down with the ship was her father, John Hatfield Cribb.

"How horrible it must have been for a sixteen-year-old girl, having lost her father on that ship!" That thought struck Lowville native Shirley Buzzell Carroll, of Lompoc, California, as she watched the movie.

Laura, later Mrs. Howard Buzzell, was Shirley's mother, and Mr. Cribb was the grandfather she never knew.

Mrs. Carroll is among seventy-five people across the nation, including at least twenty-nine in the north country, who, as descendants of *Titanic* survivor Laura Cribb, are in a sense *Titanic* survivors themselves. Mrs. Carroll's brothers remain near to where they spent their childhood—Howard Buzzell in Great Bend and Ernest Buzzell in Gouverneur.

A sister, Virginia Williams, lives in Wilmington, Delaware, and another, Bette Kendall, lives in Atlanta.

Laura Cribb Buzzell.

Grandchildren, great-grandchildren and great-great-grandchildren of Laura Buzzell live in Croghan, Carthage, Natural Bridge, Pamelia, Saranac Lake, Gouverneur and Bloomingdale.

Ironically, of Laura Buzzell's children, only Mrs. Carroll, the youngest, has seen the movie. Her siblings don't want to—some because of the fiction that Hollywood mixed with fact and others because they don't wish to relive their mother's suffering.

The story of Laura Cribb, as gathered from a variety of sources, is an odyssey of struggle. Her family Bible, now in the hands of grandson Eric Buzzell Croghan, includes a record of her birth on July 24, 1895, in Newark, New Jersey. According to an interview that Mrs. Buzzell gave in 1973 in Carlsbad, New Mexico, her mother, Bessie Jane, moved to England with her children: Laura, her sister Ellen, a brother Ernest and two other brothers. The reason for the move is unknown to Laura Buzzell's descendants,

interviewed recently by the *Times*; perhaps she was from England originally and was moving back home, they suggest. Her husband, John Cribb, stayed stateside, loyally serving as major-domo (chief steward or butler) to New York railroad heir George Jay Gould.

Mr. Cribb occasionally visited his transplanted family, and on his final overseas trip, Laura said in the *Carlsbad Current-Argus* interview, she decided that she wanted to go home with him.

The word that has passed down through succeeding generations is that the trip on the maiden, and only, voyage of the *Titanic* was a birthday gift. The rest of her family, including a brother suffering from appendicitis, stayed in England.

Months later, at her mother's suggestion, Laura wrote a journal about her night of horror. The following is from her account, as it appeared on April 16, 1932, in the *Watertown Daily Times*:

> *I clearly remember that I suddenly awoke and with a slight shiver, sat bolt upright in my bunk….Suddenly, the ship gave a violent jerk and then the engines stopped. A moment later my companion (a woman with children) awoke and fervently wringing her hands, cried out, "Oh my God! What has happened?" and asked me to go find out what had happened.*
>
> *I dressed quickly and hurried out into the main passage which was rapidly filling with passengers, all asking the same question, "What has happened?" I had only been in the passage a moment when I heard my father calling to me. I answered as loudly as I could and he soon located me.*

The article did not say why she was not in the same cabin as her father.

> *After a bit of chatting, my father turned to me and said, "We will probably have to go out in the life boats for a half-hour or so as we have had an accident and they want to lessen the weight of the ship and in order for them to investigate they want some of us out of the way." But I am sure now that my father sensed and knew that something very serious had happened and that once away from the ship we would never return. Just as my father finished speaking the captain and some officers came on deck shouting "Women and children must get life belts on at once, then on deck."*
>
> *I pushed my way back to my cabin. My companion was still there. I climbed up and took down the life belts. I took one for myself after giving my three companions theirs, telling them to come out into the main passage where someone would assist them in putting them on. I rushed back to my*

What in the future lies
My God shall choose the best
His loving kindness compressing
To him I leave the rest
—

I do not know I cannot tell
What God's love may prepare
I only cannot get
Beyond my father's care
—

Choose thou for me I do not ask
To see and know my way
If I am His and He is mine
My comforter and stay
—

With every good with
from your
loving Mother
1910-1912

A portion of Laura's notes about her *Titanic* experience. *Courtesy of Maurie Pollock, Carlsbad, New Mexico.*

father who took the life belt from me and told me to hurry along to the deck. We were the first on deck so we ran swiftly across to the iron stairway leading to the second-class deck that we ascended and easily got over the little gate at the top. Then we went through the salon and to the first class staterooms and deck where the lifeboats were ready to be lowered.

As soon as we appeared the officers came up to us and told father to put the life belt on me. This he did, then telling me to get as near the lifeboats as I could. I then left him. Neither of us spoke. I expected to meet him again soon.

I was not able to get into the first two boats, but was put in the third.

What apparently occurred at about that moment was not quoted from her journal, but her interviewer in Carlsbad reported, "Laura remembers seeing a man shot while she was waiting for her boat to be filled."

The journal continues:

When we had been lowered about half way down one of the pulleys got stuck and we all thought we would be overturned into the angry sea, but it started working again just in time to prevent such a calamity.

We had a very difficult time getting away from the Titanic, as the suction was so very strong, but the sailors with the help of four women passengers managed to get away from the sinking ship. There was very little panic, as the truth of what had happened was not known to many of the passengers until we were away from the ship. Then we could see for ourselves what had happened, although we didn't realize just what it meant to us.

We had only been out about a half-hour when suddenly the lights of the ship went out. Immediately there was a terrific explosion mingled with the shrieks and moans from the helpless and doomed passengers who were left on the wreck of the great ship. The explosion caused the ship to split in half, the stern straight in the air, and then it sank rapidly.

Since leaving my father I had not uttered a word, but as soon as the ship sank, they tell me I gave one awful shriek and fell unconscious. When I became conscious again...I asked how long I had been unconscious and someone told me six hours. I was pretty well frozen and my limbs ached for having the life belt on all this while.

After a while the quartermaster in charge of our boat lifted me up a little and pointed at the Carpathia to which we were rowing...In about an hour and a half we reached her. I was so stiff with the intense cold that I could not climb the rope ladder, so I had to have the belt and rope adjusted under my arms and around my waist. As soon as I reached the top, two

blankets were thrown about me and I was carried to the salon which served for an emergency hospital that morning. Later I was helped to a cabin where I was given medical attention.

Next morning I...found everyone searching the bulletin board for news of their loved ones. It was not until then and later that I fully realized what it would mean to me. For my father had gone down with the ship. However, all the way to New York, I kept thinking that my father would meet me in New York, that he would have been picked up by some other boat, not allowing myself to believe it was true that he had perished.

After arriving in New York and answering a few questions, she was taken to St. Vincent's Hospital. There, she was found by her mother's brother and taken to his home in Newark, according to the Carlsbad account.

She was ill for two months and then in June, apparently undaunted by her trauma, took a ship to England.

She would cross the ocean several more times. On one of those voyages, according to her Carlsbad interview, she met her future husband on the way to America.

Howard Marsh Buzzell, from Windsor, Vermont, had gone to England as a civilian mechanic, helping to build up the British war machines for World War I. If he met Miss Cribb en route to the United States, then there was another boat ride back, because he and his bride were in Parkstone in Dorset, England, to take their vows on November 12, 1916.

Laura Buzzell moved back to the United States, eventually settling in Schenectady. Their oldest son, Howard, estimates that it was about 1930, when he was eight, when they moved to Shady Avenue in Lowville.

Because it was the Depression, Howard Buzzell surmises that his parents went to Lewis County looking for work. His father was taken on as a mechanic by a car dealer, possibly Charles H. Arthur Motor Sales, on State Street in Lowville. The cash-strapped couple, then with four children, was forced to send Howard to live with his paternal grandparents.

Shirley, the youngest of the couple's children, was born in 1934 in Lowville. Approximately six years later, Mr. Buzzell was hired as an electrician at Rushmore Paper Co. in Gouverneur, and he moved his family to Park Street in that village.

As an asthmatic, Mrs. Buzzell found the north country climate too uncomfortable, her children said, so about 1945 they uprooted, planting new stakes in Phoenix, Arizona. Two years later, they made their final move, with Mr. Buzzell going to work in a potash mine in Carlsbad.

Tales of "Times Gone By"

Mrs. Buzzell died on April 4, 1974, surviving her husband by thirteen years. Her children said that she occasionally spoke of her *Titanic* experience.

"That's probably why I'm not interested in getting on a ship," said daughter Bette Kendall in Atlanta.

"She'd get too upset," Shirley Carroll said. "I was a teenager when she talked most about it. Like any teenager, I didn't listen. Now I can think of questions I'd like to ask her. I'll have to wait until I see her again."

The journal of Laura Cribb Buzzell is no longer in family hands. Following her death, it was given by one of her daughters to a neighbor in Carlsbad, New Mexico. In June 2007, it sold for $16,810 at Christie's Auction.

IN THE END, A HERO

T ell my son Gordon that his father tried to be brave," said a Carthage
dentist as he painfully gasped for breath on his deathbed.

According to news stories of the day, Dr. Gordon B. Jacobs, thirty-two, was
able to talk through the night despite congestion in his lungs caused by inhaling
the fumes of burning gasoline and kerosene. His wife, Evelyn, kept an eighteen-
hour vigil, pleading with him to keep on breathing. But finally, on that Sunday
morning, February 20, 1927, his courageous fight to survive ended.

Besides his wife, at his bedside in Watertown's House of the Good
Samaritan was Dr. Charles D. Miller of Carthage. To the people of Carthage,
Dr. Jacobs died a hero. Never mind that the woman he had tried to save,
forty-one-year-old Hattie Langtry, also died.

The village on the south extension of Jefferson County, with its unfair
share of fire losses in history, had suffered another tragedy by fire. This
particular loss, reported the *Watertown Standard*, "cast a spell of gloom over
the entire village."

"His ideals of physical perfection were unsurpassed," said Dr. Frederick
G. Metzger during a Rotary Club memorial for Dr. Jacobs. "His religion and
self-sacrifice came first in his life's activities; he had all the sterling qualities
of a real man and he always had the love of family and mother at heart."

Another Rotarian at the time, the Reverend C.C. Frost, said of Dr. Jacobs,
"He was always striving to help somebody else."

He was a north country boy who stayed in the neighborhood. Born on
September 24, 1895, in East Rodman, Gordon Jacobs was the first of two
sons of Albert and Carrie Jacobs. The family moved to Copenhagen soon
after their second child, Cedric, was born in April 1900.

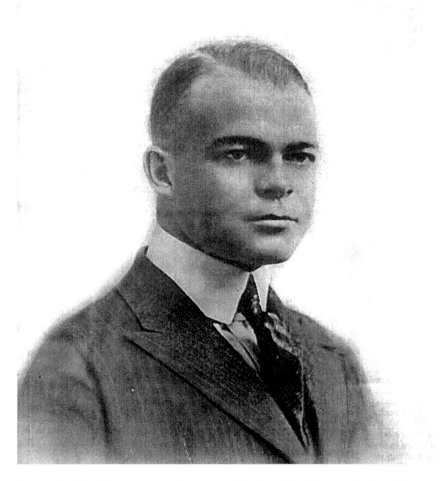

A portrait of Dr. Gordon Jacobs hangs in the Carthage Free Library. *Courtesy of the Watertown Daily Times.*

After graduating in 1913 from Copenhagen High School, Gordon saved some money by teaching for a year. He entered the University of Buffalo, but combat in Europe delayed his career goals. Army duty called in 1917, and he was sent to Fort Dix, New Jersey, for training.

The army gave him leave to complete his studies at Buffalo, where, in 1918, he received a doctor of dental surgery degree. A return to military duty placed him, commissioned as a lieutenant, with the army's dental service at Camp Sheridan, Illinois, where he readied for overseas duty.

Tales of "Times Gone By"

Lieutenant Jacobs was suddenly called on December 4, 1918, with shocking news from home. His fifty-three-year-old father, a blacksmith, had died from a broken neck in his garage. While the elder Jacobs was retrieving board partitions from a loft, his ladder slipped, causing him to fall ten feet to the concrete floor, breaking his neck.

The armistice that ended World War I also curtailed the dentist's travel plans. Instead of Europe, Carthage was his destination. He arrived about February 1919 and purchased the practice of Dr. Charles C. Hotis, a dentist who had died three years earlier.

Dr. Jacobs's new practice was in a second-floor office of the three-story Dunlap building on the south side of State Street's 300 block. He also set up a part-time office in Copenhagen.

Now that he had established himself professionally, Dr. Jacobs had some personal business to attend to back in Buffalo. On July 21, 1919, he married Evelyn M. Perkins in her parents' home.

The young couple had a bungalow built at the corner of West and Thorpe Streets in Carthage. On June 15, 1921, they welcomed an addition to their household, a son whom they named Gordon B. Jr.

Dr. Jacobs wasted no time involving himself in his adopted community. He joined the Rotary Club, became a chamber of commerce member and was elected a trustee of First Methodist Episcopal Church. Perhaps most notably, he served as a scoutmaster and group leader for the Boy Scouts.

Still in touch with his birthplace, the sportsman was a member of the Rodman Gun Club. Although it was the dead of winter in 1927, Dr. Jacobs was already looking forward to autumn, when he planned to vacation in the Canadian woods to hunt moose.

Saturday, February 19, was a typical north country winter day. There was snow on the ground, and the mercury was slowly climbing to a midday reading of about twelve degrees. On the third floor of the Dunlap building, Hattie Langtry was doing something that was apparently typical for her. She was heating a pail of gasoline on the register.

"Mother was washing my dress in gasoline," her daughter, Margaret, would later tell authorities.

Anna Weaver, a third-floor neighbor, stopped in for a visit about 11:30 a.m. and observed Mrs. Langtry doing the laundry in that manner.

Moments later, after returning to her apartment, Mrs. Weaver and her mother-in-law, Myrtle Weaver, heard a commotion next door, but they thought little of it. They assumed that Hattie and Margaret were fooling together, as they often did.

What they didn't realize was that gas fumes had reached the oil stove in the kitchen, and with a *poof!* flames had erupted.

Anna Weaver left to mail some letters. When she returned, she told District Attorney E. Robert Wilcox that she "could see red flames through the window."

"I opened the living room door of the apartment and stepped inside," she continued.

She was met by Margaret Langtry, Myrtle Weaver later told a *Watertown Daily Times* reporter, and the girl screamed, "Our apartment is on fire and mama's clothes are burning."

Margaret, who was twenty-two, fainted.

Anna Weaver, forty-five, ran into the apartment. The *Carthage Republican Tribune* quoted her as saying, "As I got to the dining room door, I saw Mrs. Langtry on the floor with her clothing on fire."

She rushed downstairs, screaming "Help!" and "Fire!"

Hearing her yell, Dr. Jacobs exited his office, grabbed a fire extinguisher in the hallway and ran up the flight of stairs. Anna Weaver continued to the ground floor, went outdoors and shouted across the street to some men in front of the Grand Union Hotel, asking them to call the fire department.

The phone call was already being made. Leon F. Marilley, a cashier at the National Exchange Bank, from which the smoke could be seen, was on the line urging an operator to hurry his call to the fire department.

Henry Ehart, another third-floor Dunlap resident, entered the Langtry apartment just before Dr. Jacobs arrived. He saw a five-gallon pail resting on a chair in the dining room, with "just a little flame in it," he told the district attorney.

> At our left as we entered was the room where the fire started. Dr. Jacobs rushed into the room and started to hold the fire extinguisher in the chair. I yelled to him that I would throw the pail out the window but he did not hear me in time. When Doc held the extinguisher in the pail the short hose seemed to get away from him and it flew out of the pail and seemed to force the flames over toward Mrs. Langtry, who was on the kitchen floor.

The victim's husband, William Langtry, who worked in the ground wood mill of West End Paper Co., was sleeping when the fire erupted. He emerged from the bedroom after Dr. Jacobs and Mr. Ehart entered the apartment and went toward his wife.

Mr. Ehart shouted, "We better get out of here!" He then ran back to his apartment to evacuate his family. He assumed that Dr. Jacobs followed him out.

Tales of "Times Gone By"

A window exploded, spraying debris around him as Henry Ehart led his family out of the building. Meanwhile, Fred E. Knapp, a fifty-five-year-old salesman for James R. Miller Co., a clothing store in Watertown, was on the street witnessing the sudden frantic activity. He hustled up the fire escape at the rear of the building, followed by the village police chief, Henry M. Andre, fifty-three.

Myrtle Weaver, eighty-one, was in her apartment. Mr. Knapp tried to lead her to the fire escape, but she refused to go.

"I didn't want to leave the place," Mrs. Weaver told a *Times* reporter. She was confident that the fire would soon be quelled.

Mr. Knapp shouted to Chief Andre for help. Mrs. Weaver recalled:

> *They continued to persuade me and at last I agreed to let them take me down the fire escape which at best was a very dangerous procedure. The two men tied a rope about me and secured me to Mr. Andre, who after much effort, because of the difficulty in descending the fire escape, landed me safely on the ground.*
>
> *I never want to go down that fire escape again.*
>
> *I never hugged a man before but I bet I hugged that policeman so hard that I almost choked him. He told me to hang on, and I hung on for dear life.*

On State Street, people started asking about Dr. Jacobs. William Langtry, with his face and hands burned, had emerged, but nobody had seen Dr. Jacobs come out.

Mr. Ehart ran back up to the third floor, but now the door to the Langtry apartment was closed, and he could not open it.

The chemical firefighting equipment and power pumper had arrived. Fire Chief Eli O. Foley, in the second of his seven years at the department's helm, had his men running three sets of hoses up two flights of stairs to the fire. They forced open the door, discovering why Mr. Ehart had been unable to open it.

Dr. Jacobs was on the floor, leaning against the door. The door had shut on him in the excitement of escape from the apartment, and he had been unable to reopen it because the inside doorknob was gone. Overcome by fumes and intense heat, he had collapsed.

At the opposite end of the room was the body of Mrs. Langtry, burned beyond recognition.

Some volunteer firefighters carried the faintly breathing dentist into the hallway, while others succeeded in confining fire damage to the Langtry apartment.

On the street, people watched in silent horror as firemen carried Dr. Jacobs outdoors. "So serious were his burns that when he was being carried from the building he was not recognized by friends," the *Watertown Standard* reported.

He was taken across the road to the Grand Union Hotel, where four doctors administered treatment, preparing him for transport to Watertown.

His wife, having been summoned to the hotel, had not been warned that he had been burned. Grief-stricken, she accompanied him in the ambulance to the House of the Good Samaritan, where, shortly after arrival, he regained consciousness.

"I guess this will be my last trip to a hospital," he said to her.

In the hours that followed, Dr. Jacobs's fraternal brothers in the Rotary Club offered to supply skin for grafting. Their offers would not be needed.

At 2:00 p.m. February 22, 1927, all businesses in Carthage closed for the funeral of Dr. Jacobs at First Methodist Episcopal Church. The church's auditorium and Sunday school room were filled to capacity.

Burial was in Fairview Cemetery in Carthage.

The following day, the Rotarians began an effort to sponsor Dr. Jacobs for consideration for a posthumous award by the Carnegie Hero Fund Commission in Pittsburgh, Pennsylvania. However, the award would not be forthcoming.

Dr. Charles Miller had a second patient as a result of the fire—Margaret Langtry. She was not told of her mother's fate until the day after the fire.

Margaret and her father, who was also being treated for his burns, were able to attend the funeral for Hattie Langtry on February 21, 1927, at a private home.

Mrs. Langtry was a native of Edwards, born to William and Estella Barnes Allen on July 12, 1885. She was brought up on a farm at Pitcairn Forks, near Harrisville, and on August 27, 1903, she was married in Gouverneur to William Langtry, who had come from Brockville, Ontario. The couple moved to Carthage about 1921.

Myrtle Weaver survived the fire and her ride down the fire escape by only two months. Her health began to decline following the experience, and on April 1, 1927, the widow of Civil War veteran George Weaver suffered a stroke in her Dunlap apartment. She died on April 22, 1927, in her daughter's home at 231 West Street.

The widow of Gordon Jacobs returned to Buffalo and in June 1932 became the wife of a Buffalo publisher, Burt H. Beard. She eventually moved to San Mateo, California, where she lived with a third husband, C.E. Bull.

Gordon Jacobs, the boy who was not yet six when his father died a hero, graduated from Carthage High School in 1939. He attended Union College in

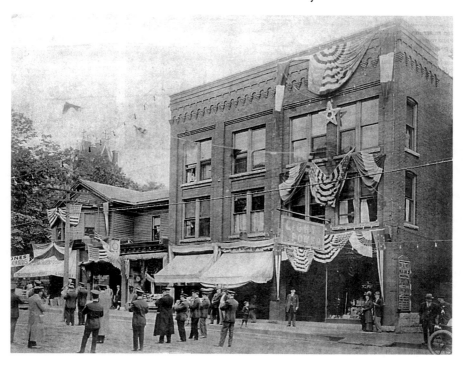

The brick Dunlop building on State Street in Carthage after 1912. *Courtesy of the Carthage village historian.*

Schenectady and was an instructor in electrical engineering at Massachusetts Institute of Technology in Cambridge for a year. At the time of his marriage in June 1944 to Mary R. O'Hearn of Chestnut Hill, Massachusetts, he was an engineer in radio research laboratories at Harvard University. In the years that followed, he worked for General Electric, Raytheon Corp., Diamond Instrument Co. and Submarine Signal Co. and spent five years in Alaska as an instructor in electrical engineering. He and his wife had five children.

The hero's brother, Cedric E. Jacobs, remained a Copenhagen resident to the day of his death in August 1943, the forty-three-year-old victim of a cerebral tumor. He had operated a garage in the village. Cedric Jacobs and the former Mary Perger had a son, Howard.

The fire victim's husband, William Langtry, retired from millwork in 1939 and died at age seventy-three in November 1947. His daughter, Margaret, married Roy V. Menard three months after her mother died. The couple lived in Lowville and had a son and two daughters. Mrs. Menard was eighty-two when she died in April 1987.

The Langtrys' neighbor Anna Canfield Weaver was a widow when the fire occurred. Five years earlier, her husband, John H. Weaver, Myrtle Weaver's son, had died at age forty-nine. Her daughter, Nellie, who later became Mrs. Eason L. Simmons of Watertown, was living with her on that fateful February day.

Anna Weaver moved to Rochester in 1929. She lived to be seventy-one, dying in November 1952 in an Ogdensburg hospital.

Like Mr. Langtry, Dunlap building resident Henry Ehart worked in Carthage paper mills. He was a widower and an eighty-nine-year-old nursing home patient when he died in January 1960. A daughter and son survived him.

Henry Andre, who was born in a log cabin at Kirschnerville, spent twenty-two years as Carthage police chief, retiring in April 1939, when he was sixty-five. He died on March 2, 1957.

The chief's companion in rescue, Fred E. Knapp, died on November 29, 1935, at the age of sixty-four, after he collapsed at Washington Street and Flower Avenue East in Watertown. The father of three had spent forty-six years selling apparel at J.R. Miller Co.

Up to the time of Eli Foley's death in March 1948, he could boast that he had spent two-thirds of his sixty-four years as a member of the Carthage Volunteer Fire Department. He resigned as fire chief in 1933 to work for the village as a fire truck driver.

Dr. Jacobs's attending physician, Dr. Miller, closed his practice of six years in Carthage in 1929 to move to New York City. A year later, he resettled in Syracuse. Illness claimed his life in January 1947, when he was fifty-one. His wife, the former Helen Wilder of Watertown, and a daughter were among his survivors.

The Dunlap building was purchased in 1954 by W.T. Grant Co. and was razed to make way for a new store. The Grant store closed in 1976 and was eventually demolished.

Laura Prievo, Carthage historian, has proven herself to be a most able and willing source in assisting this writer. The contributions of Robin Spaulding and Kate Fazio at Copenhagen Central School; Debbie Hartshorne, Carthage Central School; Times *librarians Esther Daniels and Lisa Carr, and* Times *staff writer Steve Virkler are also acknowledged and appreciated.*

HEROES AND VILLAINS

B urt E. Jarvis followed his hunch, and it paid off—for a little boy and for himself. A fan of a new marvel, commercial radio, he had heard over the static-filled airwaves about the abduction of a lad in Schenectady. And he had seen the child's picture in the *Watertown Daily Times*.

Mr. Jarvis, operator of a boat livery on the Indian River at Theresa, had recently made the acquaintance of a couple of suspicious characters. Soon after, there came word of something fishy going on at a remote stone cottage he had rented to the strangers. An old woman and a child were staying in the hideaway, a passerby told him.

This did not mesh with the plans the strangers had expressed to him.

"Then I got the hunch that this was the kidnapped child and I determined to look into it," he told reporters.

Late in the afternoon on May 3, 1923, the fifty-one-year-old boatman (also the village barber, with work as a school janitor not too far off in his future) became a hero. After confirming his suspicion, he led a Jefferson County deputy sheriff to the rescue of five-year-old Verner Alexanderson, kidnapped son of Ernst F.W. Alexanderson, who was called "the most expensive man in radio."

The next day, a grateful father was pressing $1,000 into Mr. Jarvis's hands. Later in the month, Jarvis was being applauded in a theatre in Schenectady, where another $1,000, drawn from "popular subscription," was awarded to him.

Finding himself in the midst of an ovation in the city's Proctor Theatre, Mr. Jarvis modestly stood and bowed to the people. And then he went about the business that had brought him to Schenectady—to tell a grand

With the kidnap experience a few months behind them, Verner Alexanderson spends time with his father, radio pioneer Ernst F.W. Alexanderson. *Courtesy of Ernst F.W. Alexanderson II, Manville, New Jersey.*

jury about the woman he had found tending to the young hostage and about the two men he met in Theresa, villains from Alexandria Bay and Sackets Harbor.

The story that captivated New Yorkers—indeed, much of the East Coast, thanks to the dawn of radio—opened about six years earlier in New Jersey.

That's where a young soldier from Sackets Harbor, Stanley G. Crandall, met a chap operating a soda fountain in a small town on the outskirts of Camp Dix. They found that they had something in common on which to build a friendship. The soda jerk, Harry C. Fairbanks, also was from the north country. He had grown up in Ogdensburg.

Crandall was off to war in France in 1918 and 1919, and soon after his homecoming he began to look up old friends, including Fairbanks.

"He possessed a very keen, active mind, quick to take advantage of the other fellow's errors," Crandall wrote of Fairbanks in 1927 for the *Albany Evening Union*. (The story was reprinted in the *Watertown Times*.) "Things were to him a thought one moment and an actuality the next. He was impulsive in every action, regardless of the consequences."

Fairbanks had ties to Schenectady, and during a mid-April 1923 visit there, he explored that city's more exclusive residential area. He saw a boy and his two sisters playing outside a distinguished home and struck up a conversation with them. He asked if they would like to have some rabbits.

Sure, they said. He promised to look into it for them and went on his way.

His stop had been at the home of Ernst and Gertrude Alexanderson. The provider in this household was chief engineer for General Electric Co., a man much in demand for his inventiveness in the burgeoning radio industry.

The Swedish-born scientist had created a high-frequency alternator to convert direct current into alternating current, improving radio communication; he had also devised a selective tuning device for radios. His future innovations would be the first transmitted facsimile, or fax, across the Atlantic in 1924 and the first home reception of television—in his home, of course. Of the 322 patents he would accumulate during his career, one in 1955 would be for a color television.

The stage was being set for a crime. But was Fairbanks looking for a big ransom?

Crandall was married and living in Rochester, looking for work. Come to "the Bay," his old buddy Fairbanks urged. Summer employment would be plentiful.

Fairbanks had settled down with his wife at Alexandria Bay and, according to the press reports that would follow his crime, was involved in a busy border town trade of that era. He was a rumrunner, police said.

Taking up the invitation, Crandall estimated that he arrived at Alexandria Bay on April 17.

"I found I was much too early [to be applying for summer jobs]," he wrote.

On the nineteenth, he accompanied Fairbanks to an island cottage ten to twelve miles downriver. He bowed out of a poker game after the stakes got too high that night and, upon rising the next morning, learned that Fairbanks had lost $700 to their host, a Mr. Ellis.

Fairbanks retreated to Ogdensburg to get more cash and, while there, rented a Cadillac touring car. When he got back to Crandall, he said that he was making arrangements to get a large supply of fancy liquor to sell in the summer to Thousand Islands tourists. He needed to find a place to store the beverages outlawed by the Volstead Act.

As the pair later drove through Theresa, they noticed a sign advertising cabins for rent along the Indian River. They tracked down the owner, Burt Jarvis, who set the date of a meeting as either April 26 or the following day.

They told Jarvis that they were brothers and Miller was their name, Mr. Jarvis told police. They wanted a cottage for their young sister, who was recuperating from throat surgery, they said. Mr. Jarvis took them to a cottage about three miles north of Theresa. A deal was struck that day, and a five-dollar down payment was made.

"A more inaccessible spot and one better suited for the purpose to which it was put could scarcely be found in the North Country than the cottage at Stony Point," the *Times* reported.

> *There is hardly a wilder or more desolate region to be found in this section of the state.*
>
> *Precipitous bluffs, in many places rising straight up 70 to 80 feet, make the cottage inaccessible except by boat or by a rough little used country road. No other parties would be likely to be in the vicinity at this season and there are no nearby farms.*

Then came that fateful day, "a wonderful spring day, cloudless and serene," Crandall recalled.

The two men started for Rochester, but then, according to Crandall, Fairbanks suggested an alternate destination. Now that they had an ideal location to set up a still and make whiskey on a large scale, Fairbanks knew a person in Schenectady from whom he could buy a large quantity of alcohol. They parked, and Crandall waited for Fairbanks to conduct his business.

Crandall maintained that he was unaware of his partner's true mission.

At about 2:00 p.m. on Monday, April 30, Fairbanks found the three children he had visited a few days earlier. He told them that he had the bunnies he had promised and sent the girls, ages eleven and nine, to get boxes. With the girls out of sight, Fairbanks grabbed the boy and led him to the Cadillac.

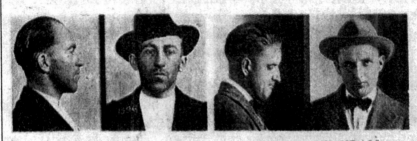

$5,000 REWARD

Wanted for Kidnapping

HARRY C. FAIRBANKS

Age—35.
Height—5 ft. 7 1-8 in.
Weight—140-5 pounds.
Slender build.
Light chestnut hair.
Light complexion.
Chestnut hazel eyes.

STANLEY G. CRANDALL

Age—25.
Height—5 ft. 8 1-2 in.
Weight—143 pounds.
Medium build.
Light chestnut hair, probably
 combed pompadour.
Medium complexion.
Medium chestnut eyes.

$5,000 reward has been offered by the General Electric Company for the arrest and conviction of the kidnappers of Verner Alexanderson, 6 years old.

JAMES W. RYNEX,
Chief of Police,
Schenectady, N. Y.

Schenectady police issued a poster announcing a $5,000 reward for the kidnappers of Verner Alexanderson. *Courtesy of Ernst F.W. Alexanderson II, Manville, New Jersey.*

He told Crandall what he had done.

"When he started to put the kid in the car, I refused to drive and climbed into the back seat," Crandall reported.

Off to Jefferson County they drove at a high speed. Their first stop was Alexandria Bay, where, shortly after midnight on Tuesday, Fairbanks recruited his grandmother, Harriet D. Grinnell, sixty-six, to baby-sit. He was taking care of the son of a friend's sister, he told her, and the mother would be coming to Theresa later in the day to pick up the boy.

Fairbanks and Crandall left Mrs. Grinnell and Verner at the cottage at noon and then sought out Mr. Jarvis to pay another five dollars on the rent.

The two men seemed "uneasy," Mr. Jarvis said.

Later that Tuesday afternoon, a stranger arrived at the cottage with a note for Mrs. Grinnell.

"Am called away for a few days but will send your pay weekly," Fairbanks had written. "The family will be with you Saturday May 5."

The abduction was not reported until 6:00 p.m. Monday. Afterward, no time was wasted in getting word out on commercial radio about the crime. Up in Theresa, Mr. Jarvis was listening to the report on his radio.

Schenectady police, meanwhile, received a quick lead on the getaway car. It had been held in storage briefly in a garage in Schenectady, and the property keeper had a habit of jotting down license numbers. In Albany, the secretary of state's office was able to trace the plate: it belonged to Edward Kiah of Ogdensburg.

Schenectady police Detective Benjamin S. Van Deusen drove to Ogdensburg, where, with the assistance of local police, he interviewed Mr. Kiah and learned who had possession of the auto. Police had the name of a suspect: Harry C. Fairbanks.

On Wednesday evening, May 2, Fairbanks read in a newspaper that the kidnap car had been traced to Ogdensburg.

"I realized I was as deeply involved as Fairbanks," Crandall wrote. "Our only chance, we decided, was in flight and Canada was the only logical place to go."

At about 1:00 a.m. on Thursday, May 3, they parked the car near Weller's garage at Alexandria Bay and scouted for a boat on which to flee the village. Fairbanks saw some men, among them Detective Van Deusen, go to the home of village police chief James Crabb. The pair rushed to a boathouse and boarded a small boat just as lawmen were surrounding the nearby Fairbanks home. Under the cover of darkness, they slipped away, eventually carried by the river's current to a Canadian shore twenty-two miles distant, according to the Crandall diary.

Later that Thursday morning, Mr. Jarvis received word about an old woman and a child staying in his cottage. He went to investigate. After knocking at the door, he heard the woman say, "Keep still." When she opened the door, he asked for a drink of water and stepped in. He saw a boy lying on a bed and waved his hand at the boy. The child waved back, but said nothing. The woman appeared uneasy.

Mr. Jarvis was certain that the child he saw was the same boy pictured in the *Times*. He returned to Theresa, consulted with Postmaster Eldridge J. Stratton and called Sheriff Ernest S. Gillette in Watertown. The sheriff sent out Deputy Fred V. Jackson.

Arriving at the cottage late in the afternoon, the deputy, the property owner and the postmaster took positions at the front and rear entrances. Deputy Jackson entered through the rear door, whistling to his "posse" to enter at the front.

A frightened boy, just sixteen days away from his sixth birthday, began to cry.

"I'm going to take you back to your mamma and daddy," the deputy assured him. "What's your name?"

The boy gave the expected answer, "Verner Alexanderson."

Deputy Jackson asked him who the woman was.

"Grandma," the boy said.

Deputy Jackson took Verner and Mrs. Grinnell to Watertown, where, at the sheriff's office, he placed a call to Schenectady. Ernst Alexanderson picked up the phone and listened as a man named Jackson announced, "We have recovered your child."

Minutes later, Mr. Alexanderson was at a radio broadcasting station in Schenectady telling an audience of thousands that his son was safe. Many in Watertown heard the announcement, the *Times* reported.

Detective Van Deusen received word of the rescue while having dinner at the St. Lawrence Hotel at Alexandria Bay. He immediately set out for Theresa and then Watertown.

Shortly after eight o'clock that night, Kate Gillette put the child to bed. Too excited to go to sleep, he asked the sheriff's wife to tell him some stories. She obliged him, and after about a half hour, the boy dropped off to sleep.

The 7:07 a.m. arrival of a train at Watertown's New York Central train station the next day brought two anxious parents and Owen D. Young, chairman of the board at General Electric.

Deputy Jackson met the visitors and drove them through Public Square and up Court Street to the sheriff's office for a joyous reunion.

They were also introduced to Mrs. Grinnell, who was in custody as a suspected accomplice. The mother's initial scorn toward this woman soon softened when Mrs. Grinnell handed her a letter. She had figured out that she was baby-sitting for the kidnapped boy and had written a letter to mail to the family, telling them where he could be found. She hadn't had a chance to mail it, she said.

Meanwhile, Fairbanks, thirty-six, and the man now identified as his accomplice, Crandall, twenty-seven, were still at large.

"I don't care what it costs," Mr. Young said, announcing a reward. "We want to land the men who kidnapped the Alexanderson boy."

It would take a while.

The fugitives arrived in Montreal only to learn that police there were on the alert for them. They slipped back into the United States and headed west. Crandall reported that they parted company at Salt Lake City, Utah.

A grand jury in Schenectady issued sealed indictments for the arrests of the two men and also indicted Mrs. Grinnell as an accomplice. She was brought to trial in June but was acquitted.

Fairbanks's flight from the law ended on July 18, 1925, at Fall River, Massachusetts, where he was caught passing a worthless bank draft. He was using the name Harry Christie, but his fingerprints and photo gave him away.

"I don't know why I kidnapped the boy unless it was because I was under the influence of Crandall," he told police. "Possibly I was drinking on the day I took the boy."

On November 18, 1925, he pleaded guilty to kidnapping. His lawyer claimed to a judge in Schenectady that the crime had been planned by Crandall, but that did not spare him from a ten- to fifteen-year prison sentence.

Crandall had a more storied life as a fugitive, worthy of the print that the Albany and Watertown papers gave him. He was constantly on the go, traveling the length of the West Coast and into Mexico and Canada. He told of a close call in a Western Union office in Los Angeles, where he bumped into an old friend from back East. They lunched together and even discussed the case. Crandall agreed to meet the man again later in the day but had second thoughts and stood him up.

In Vancouver, British Columbia, he was sitting in a hotel beer garden when a man recognized him.

"I beg your pardon," the man said. "Is your name Crandall?"

Offered a denial, the man, who was from Gouverneur, said, "You have a double in New York State."

CARTHAGE, N.Y.

Burt E. Jarvis, shown with his wife, Millicent, led the sheriff to the missing child. *Courtesy of Gayle Green, Beaver Falls, New York.*

Crandall quickly moved on to Seattle, Washington.

Later, back in Los Angeles, he landed a job selling advertising at a motion picture corporation, and his good looks and personality earned him an offer to go on location, to appear as an extra in filming.

"It meant more money and a possible career," he wrote, but "I knew it was impossible for me to be seen. There was nothing left for me to do but resign and seek a less dangerous occupation."

He spent three years as a traveling salesman, peddling fountain pens. And he gambled, perhaps wanting to get caught. A friend was compiling a traffic ordinance book and in doing so was working closely with the police department in Aberdeen, Washington. Crandall agreed to assist in the project and found himself almost arm in arm with police officers.

He remained undetected until October 8, 1927, when he helped break up a fight in a rooming house where he was staying. An Aberdeen police

officer arrested him because of the disturbance, and his fingerprints and photograph were taken.

The police chief summoned him to his office a day later and, showing him a photograph, asked, "Did you ever see that fellow before?"

"It was my picture, taken in 1915," Crandall said in his newspaper account. He had his time as a fugitive counted to the day: "Just four years, five months and five days."

"I can say in all sincerity that I was glad to go back and face that from which I fled in 1923," Crandall wrote. Of the punishment he was about to face, he said, "I wonder if it can be any worse than the four and a half years of torture which followed the kidnapping."

After his return to Schenectady, he told police that the kidnapping was a screen for bootleg operations. But the district attorney, Alexander T. Blessing, said, "I would have advised him to steal a bigger boy, one who could have helped him lift things around in his proposed bootlegging operations."

Crandall was sentenced in December 1927 to five to twenty-five years after pleading guilty to attempted kidnapping. He refused to plead guilty to kidnapping.

He served five years and was paroled in August 1931. He returned to Rochester, where he became a car salesman. His partner in crime spent fourteen years in prison. Fairbanks was granted parole in November 1939.

Mrs. Grinnell did not live to see Stanley Crandall brought to justice. She was seventy years old when she died on March 6, 1927.

Fred Jackson had been a deputy sheriff for two years when he answered the call to Theresa in 1923. He remained with the department until March 1940 and died thirteen years later at the age of sixty-two.

Burt Jarvis was still remembered as a hero when he died on November 9, 1955. He was eighty-four.

After Verner Alexanderson was returned home, the story about rabbits struck a sympathetic public. The family received more than twenty rabbits as gifts, according to Ernst F.W. Alexanderson II of Manville, New Jersey, Verner's only son.

Verner attended Amherst College and then Harvard before entering a forty-year career as a chemical engineer with America Cyanamid Co.

When he married Elizabeth Lapham Mitchell in New Jersey in 1941, his bride took offense at the headline in the *New York Herald Tribune*, "Kidnap Victim Marries," according to his son. She was likely unaware of the *Watertown Daily Times* headline on March 3, 1941: "Verner Alexanderson, Kidnap Victim of 1923, Takes Bride."

Tales of "Times Gone By"

A sailboating hobbyist, Verner Alexanderson died on February 12, 1999, in Lee, Florida.

According to his son, the family's understanding of the kidnap motive was that it was not for a ransom. Fairbanks was said to have wanted to give the boy to a female acquaintance who wanted to raise a child.

My thanks go to Gayle Green of Beaver Falls, a granddaughter of Burt Jarvis, and Ernst "Rik" Alexanderson II for their assistance in this story, as well as to Times *librarians Lisa Carr and Esther Daniels.*

PRESCRIPTION FOR SUCCESS

B urt Kinney walked in the door of his drugstore in Gouverneur, grabbed his broom and dustpan and went about his daily ritual of sweeping the floor. This wasn't quite like any other workday in the Main Street store.

The employees went about their business, but today they were excitedly following the company patriarch out of the corners of their eyes. Today, they were confident, B.O. Kinney would find no dirt and would have no criticisms about their work.

But who would get the last laugh? Norton W. Taylor, an eventual president of the company, was managing the store at the time, sometime between 1954 and 1966.

Every morning, despite his crew's diligent efforts at sweeping and mopping, Mr. Taylor prepared himself for the final inspection by the kindly gentleman for whom the company was named. "He'd still find some dirt," Mr. Taylor said.

So one day, the manager and his crew determined to surprise B.O., perhaps even leave him speechless.

"I told the guys to really sweep good, so we came in early and we cleaned every nook and cranny."

An air of anticipation climbed as Mr. Kinney walked in at about 10:00 a.m., his usual arrival time. He made his rounds and then approached Mr. Taylor.

Astonished, Mr. Taylor heard some familiar words.

"Nort," said Mr. Kinney, "your boys didn't do very well this morning."

Laughing probably as loudly now as he had on that day so long ago, Mr. Taylor explains, "We forgot to sweep out the phone booth."

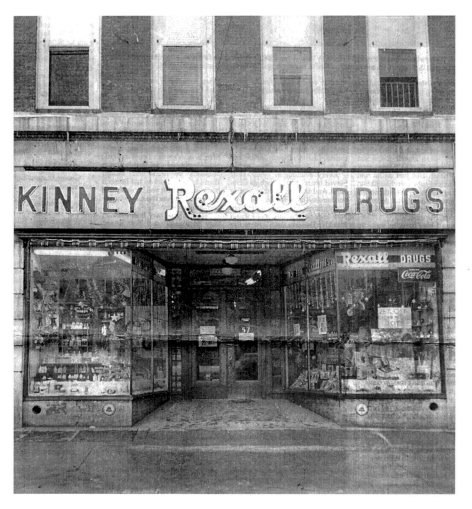

Kinney Rexall Drugs. *Courtesy of Kinney Drugs, Inc.*

Mr. Taylor holds nothing but fond memories for the man who, unaware that he was giving birth to a merchandising chain, placed the Kinney name on that storefront in Gouverneur a century earlier:

> *He was a perfect gentleman, never raised his voice. He met people at the door and knew everybody's name. When he came in in the morning, he'd reach into a candy jar, fill his pockets, then he'd talk to the kids and give them candy, gum balls and chewing gum.*

And pennies, too.

"I learned from him," Mr. Taylor continues. "You meet and greet your customers. Hopefully we have passed that on to our managers. Mr. Kinney always said, 'No matter how busy you are, customers make paydays possible.'"

In the years of his company presidency, Mr. Taylor displayed in his office a poster to pass on the B.O. Kinney message: "Just Remember—the customer is king."

Electa A. Bignall Kinney was not quite thirty-six when, on September 12, 1873, she gave birth to a son whom she and her fifty-year-old husband, Orrin, named Burt Orrin. The child was their youngest. They had another son, Austin, and a daughter, Della. Orrin Kinney, a carpenter, had another son, Andrew, by an earlier marriage.

Slight of build, Burt grew up a sports enthusiast, with skating in the winter and baseball in the summer commanding his attention. When a group of enthusiasts put together an amateur baseball squad in 1892, an eighteen-year-old Burt Kinney won the shortstop position. That team counted among its sixteen consecutive victories a 25–16 battle with the Watertown RW&O club on July 28 in Gouverneur. The Gouverneur squad's streak was on the line as it entered its half of the eighth inning with a tied score, but an eleven-run rally put it out of reach.

Teams from other villages, as well as clubs fielded by the colleges in Canton and Potsdam, also bowed to the Gouverneur group.

Burt graduated from the Gouverneur Wesleyan Seminary and earned his first dollars in the VanDuzee sawmill. Eventually, he became a drugstore clerk in the Draper store. His next employers were the druggists Dewey and Perrin.

Kinney's workweek of sixty hours netted him an eight-dollar payday. His daily starting time was 7:00 a.m., "when farmers came to town with their milk and painters came in for supplies for their day's work," according to Margaret Nulty, who wrote "Seventy-Five Years 'Near You'" for the *Quarterly*, published in 1978 by the St. Lawrence County Historical Association.

His first chore of every workday—which should be no surprise to Mr. Taylor—was mopping the floor. He also had to replenish the icebox and assisted in preparing ice cream and carbonated water at the soda fountain.

"He so disliked this job that he was a long time deciding to open a fountain in his own store," Miss Nulty wrote.

The store clerk got married in 1896. He was twenty-three. His bride, Kathleen Grace Draper of Gouverneur, was nineteen.

Burt Kinney. *Courtesy of the* Watertown Daily Times.

Burt's boss, A.W. Dewey, saw a future for the pleasant, hardworking young man and urged him to enroll in the Albany School of Pharmacy. With Mr. Dewey footing the bill for tuition and Kathleen staying home with the couple's two-year-old son, Harold, Burt was off to Albany in 1899. Two years later, he was filling prescriptions in Mr. Dewey's store.

Finally, in the fall of 1903, Mr. Dewey sold the business to his protégé. On September 30, the store opened under new management. Noting the occasion, the *Gouverneur Free Press* observed, "Mr. Kinney is one of the best known drug clerks in town, and has a large clientage of customers."

In 1953, Harold Kinney recalled his father's debut as a store owner: "The first day's sales totaled $157.90, and the second day, $36.04...It wasn't until December 19 of that year that the second $100 day occurred."

The first Kinney drugstore had a frontage of twenty-five feet, was heated by a single stove and was without hot water or electricity, according to Miss Nulty's report. Wiring and ceiling lamps with incandescent bulbs were installed in 1909.

Burt's merchandise arrived by train, and then by horse-drawn drays, in bulk. In stock for the buyer were skunk oil, beaver oil, bear oil, medicinal teas, saltpeter, linseed meal, resin and plaster of Paris. Two brands of cigarettes and a good variety of cigars were available to smokers, but rock candy was the sole commodity for the sweet tooth. Fifty-cent bottles of perfume and boxes of face powder and talcum powder were there for the ladies. At the pharmacy counter, there was frequent call for cascara, castor oil and strychnine tablets.

Meanwhile, in the year that followed his grand opening, Mr. Kinney wrote his own prescription for success when he signed on with a new drug distribution company. He became one of the first fifty druggists in the country, and the only one in his corner of the world, to become associated with Rexall. His store was to become known as Kinney Rexall Drugs.

With all of those cigarettes and cigars he was selling, and especially in those days when smoking was not frowned upon, Burt O. Kinney took up the habit. But just as he had some insight into merchandising, the druggist also had his suspicions about smoke and health, according to his granddaughter, Susan M. Kinney Baker of Norwich, Vermont.

"When I was born, he gave up smoking," she said. "He said it wouldn't be good for the baby."

That was in 1935. Susan remembers the kindly grandfather who treated her at the soda fountain. "When I was three or four, my mother would get one chocolate shake and share it with me. But he would give me a whole one."

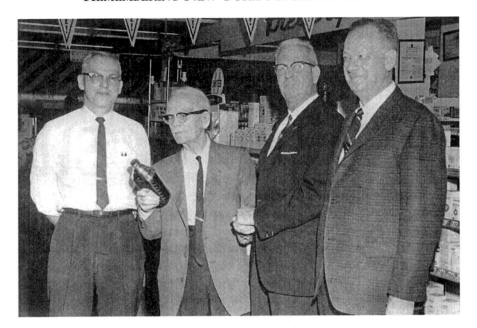

Burt O. Kinney is flanked by "Nort" Taylor (left); Wilson Dillmore, a representative of Rexall; and George D. Burgess, eventual president of Kinney Drugs. *Courtesy of Kinney Drugs, Inc.*

And she has fond memories of summer weeks when the family gathered in the Kinney cottage at Trout Lake. "He loved to fish. When anybody in the family caught a big fish, they'd trace it on the wall in the cottage and write in who caught it."

Those tracings remain today, Susan said, and the cottage is now owned by a cousin, Linda Simpson of Arlington, Virginia.

Every evening at camp, they played board games such as cribbage. And they listened to boxing and baseball on the radio. "My father and grandfather were New York Giants fans, and I was a Brooklyn Dodgers fan. I'll never forget them taking me to Ebbets Field to see Jackie Robinson and Pee Wee Reese play."

But on Saturdays, even in the summer, the elder Mr. Kinney was tending his shop. "It was the busiest day of the week," she said.

> *He was the best store clerk I've ever seen. Grampa never had a desk or an office. He worked the floor. When a customer wanted to buy a book that wasn't on the shelves, he'd dig through the stock upstairs to find a fifty-nine-cent book.*

Harold Kinney. *Courtesy of the* Watertown Daily Times.

He may have been a genial storekeeper, but Burt Kinney was not an expansionist.

By the time Susan Kinney was born, Kinney's was a two-store business, having opened in downtown Massena in 1928. Susan's father, Harold, had joined in his father's business in 1919, and as executive vice-president, he was the man who began the expansion.

"Harold was very businesslike, very intelligent," said Nort Taylor. "He made the decision on expanding."

Harold had two assistants, George Burgess and Stan Paupst, who spearheaded the expansion, going out to investigate proposed sites, Mr. Taylor said.

When Mr. Taylor started working at Kinney's while in high school, as stock boy and at the soda fountain, he was more familiar with Harold Kinney than with B.O. The younger Mr. Kinney "was a good leader," Mr. Taylor said, "but he would fly off the handle without asking questions first."

Ms. Baker concurs about her father. "He was hot-tempered," she said.

Harold Kinney went to Cornell University, majored in chemistry and graduated in 1918. He went to work for Solvay Chemical Co. in Syracuse but left that job in short order, coming home to Gouverneur to ponder his future.

"He wasn't sure what he wanted to do," Ms. Baker said. "He worked in the store while he was trying to decide, and finally he stayed because he loved merchandising."

Mr. Taylor, meanwhile, had gone off to war, serving as a radio operator in the China-Burma-India Theatre of World War II. Back home after the war, he spent his savings of $800 to buy a car, not really sure what he was going to do for a living.

"George Burgess kept calling me, asking when I was coming back to work." So, he went back to Kinney's, working as a clerk.

A pharmacist, Bill Fitzgerald, talked to me and asked if I thought about going to pharmacy school. He got me interested, so I got in my car, drove to Albany and applied. Right after I returned home, the school called me. They had a cancellation in the freshman class and offered the opening to me. I had to buy some clothes, and on the next Monday, I was in pharmacy school.

When he came home for vacations, he said, "I'd get off the train, and an hour later I was at the store. I always had a job."

Following graduation in 1949, Mr. Taylor returned to a company that had stores in Gouverneur, Massena, Adams, Potsdam, Carthage and Pulaski and was opening another store in Watertown. He was assigned to Massena, later transferred to Adams and was named manager of the Gouverneur store in 1954.

During his next twelve years, he became acquainted with the company patriarch.

He helped many people. He had a little black book in his shirt pocket where he kept notes. He let people pay as they go. I know he helped a lot of hurting people. A woman who raised bees, he loaned her money. She'd bring in beeswax, and we'd give her credit for it. A lot of people paid him fifty cents a week.

The first Kinney Drugs store opened in 1903 on Main Street in Gouverneur. *Courtesy of Kinney Drugs, Inc.*

And Mr. Taylor watched Burt Kinney fatten his bank accounts.

> *He bought stock in a company when he saw their products selling well in the store. I think he started with Miles Kimball. They came out with Alka Seltzer, which people used to use for hangovers. Then he tried Kodak and then Vicks, after they came out with VapoRub.*

As Burt Kinney advanced in years, there was a question of what was going to happen to the organization, Mr. Taylor said. Harold Kinney talked of selling the business, and he offered to sell shares of stock. Today, Kinney Drugs is employee-owned, selling private stock shares to workers.

"We all kicked in," Mr. Taylor said.

> *We'd buy stock to help in the expansion. I'd just about get one note paid off, and Harold would want to expand again. He'd ask us to buy more stock. Once, my wife planned to buy a piano, but we got stock instead. Thank heaven I did it. It went well for me.*

Burt O. Kinney, who survived his wife by four years, died on July 6, 1966. He was ninety-two.

"He was never sick," said Mr. Taylor.

"He waited on customers up to six weeks before he died," Mr. Kinney's granddaughter added.

Harold Kinney was eighty-two when he died on August 11, 1979.

Both men are remembered for their community support. Without Burt Kinney, "Gouverneur might never have had a country club," said a *Gouverneur Tribune Press* editorial in 1961. Edward John Noble Hospital in the village was well served by the philanthropy of Harold Kinney, who also gave the community its Harold and Mary Kinney Nursing Home.

Susan Kinney Baker continued to own stock in the company but resigned from active participation in the business.

> *I was on the board of directors, but I live in Vermont. When you have a family business, you either get involved or you don't. There was no reason for me to be making decisions. Historically in a family business, people want the money but don't care about the business. They can run a business into the ground. So I resigned.*

The nearest Kinney store to her is a half hour away, in Bradford, Vermont, she said. "I'm trying to get one closer, but there are a lot of pharmacies here. None are as good as Kinney's. None of them have drive-throughs."

Her son, David, works in the computer industry in Salt Lake City. As he has no children, he is the last of the direct descendants of B.O. Kinney. He is not a stockholder in the company.

Mr. Taylor was appointed superintendent of stores in 1966. The following year, he was named director of all Kinney stores and was elected to the board of directors. The year 1978 was most eventful for him: in January, he was elevated to executive vice-president, and in June he became president. In retirement, he remained on the board of directors.

Had it not been for the friendly advice of pharmacist Bill Fitzgerald, "I might have been clerking in the store for the rest of my career," Mr. Taylor said. "It was just a fluke."

When Kinney's observed its 100th anniversary in 2003, the chain had sixty-four stores, and employed 1,769 people, of whom 682 worked full time.

For their assistance in gathering information for this column, I gratefully acknowledge Annette M. Farrell, marketing relations supervisor for Kinney Drugs; the staff of St. Lawrence County Surrogate Court; Charlotte Garofalo at Gouverneur Public Library; Times reporter James Donnelly; and Times librarians Esther Daniels and Lisa Carr.

THE DARING RESCUE OF A
MINISTER'S IMPRISONED WIFE

The whispers and suspicions had been mounting for weeks in the small but busy railroad village of Quaker heritage: What about the minister's wife? Was this woman, her world limited to a one-window, second-floor room of the parsonage overlooking the Philadelphia Congregational Church on Antwerp Street, truly insane, as the preacher had described? Or was she simply a prisoner in her own home?

When trustees of the Congregational church finally lost their faith in the Reverend James Provan, they schemed to invade the privacy of the parsonage.

"The house was watched by day, and by night hired men stood in the shadow of the home," the *Watertown Daily Times* reported. The situation came to a head on a Monday afternoon, July 19, 1909, as the minister headed out to attend to personal matters at the office of town clerk DeWitt C. Aldrich.

The telephone rang at the clerk's office. A conspirator told Mr. Aldrich, also owner of the community's newspaper, the *North Country Advance*, to keep the minister interested and occupied for as long as possible.

Back at the parsonage, "sentries stood at two street corners, while another stood outside the house," the *Times* reported.

A person went to the door, and one of the minister's children, Annie, answered. "Come, mother," she called. "The men are here to take you away."

Mrs. Provan, "trembling with fear," came down the stairs, crossed over the threshold and "was hurried as fast as she could walk up the street," a few doors away to the home of Philly's most prominent citizen, Andrew C. Comstock, a sixty-two-year-old former state assemblyman.

The Reverend and Mrs. Provan had arrived in Philadelphia fourteen months earlier. Born and educated in Scotland, the minister had moved from

Mineville in Essex County, explaining that he was accepting a small church and its $1,000 annual salary in order to get his wife into the country. She, the mother of nine, was an invalid, he said, prone to violent bouts of insanity.

The village to which he moved, with its hardened dirt streets, had about 850 people. Philadelphia was served by two doctors and a dentist, a school and four churches—Methodist, Baptist, Catholic and the sixty-year-old Congregational church. Employment and home construction had been on the rise, thanks to north–south and east–west railroad lines intersecting there, according to town and village historian Gwen Acheson, who wrote a local history.

The Hayes and Eagle Hotels stood ready to accommodate railroad travelers, who could stroll over to the G.E. Evans Drugstore for an ice cream or soda. There, one could find Mr. Evans's home concoctions of tonics, syrups, ointments and drugs.

Boasting a thirteen-year-old water system and a power plant that started lighting the streets in 1904, Philadelphia was a self-sufficient community with a telegraph office, two sawmills, two gristmills, two coal dealers, three blacksmiths, a livery, a baker, a grocer, a butcher, a barber, a lawyer and a mortician, Mrs. Acheson reports.

Bringing the Reverend Provan to Philadelphia seemed a fortunate move for the Congregational trustees. Word spread that he was a talented pulpit orator, and soon attendance at church, bolstered by some of the other faiths, began to swell. His messages were learned, logical and inspiring, it was said. Often, he expounded respect for the state of marriage.

Nobody ever saw the minister's wife. But they saw quite a bit of his housekeeper, Kate Berwick.

"It was Mrs. Berwick who occupied one of the finely furnished front rooms on the chamber floor of the parsonage," the *Times* reported.

It was Mrs. Berwick whose gowns and finery were of the best. It was Mrs. Berwick who sat at the dining table, as a wife might, and ate the delicacies of the seasons. It was Mrs. Berwick who handled the money that came as the salary of the man of the household.

Who, meanwhile, was doing the washing and ironing for the household of six? It was the supposed lunatic, Mrs. Provan, whose three youngest children, Annie, Wilfred and Lyman, still lived at home.

The Philadelphia ministry of the Reverend Provan had gone smoothly for the better part of a year when a village man returned home from his commercial travels. One of his stops had been Mineville. The people there

Tales of "Times Gone By"

The Philadelphia Congregational Church and its parsonage. *Courtesy of the Philadelphia village historian.*

were still speaking about the Reverend Provan, he reported. They were not fond recollections. The fact was, the traveler said, "he was a crook," according to the *Times* account.

Church trustees confronted their spiritual leader and were, for the time being, satisfied with his response. The fine people in Mineville, he said, had given him parting gifts of a horse and buggy and a $300 purse.

But evidence to the contrary began to mount. His son, Wilfred, wrote a check that was returned by a Port Henry bank marked insufficient funds. The Philly banker wrote an inquiry, and the answer from Port Henry noted that the boy's father "although a minister, was crooked."

When approached a second time, the minister satisfied his trustees with an explanation. But then, as is wont in this small world, came a coincidental meeting in Grand Rapids, Michigan. Mary Comstock, the retired lawmaker's wife, was visiting there when she happened to meet a twenty-four-year-old named Fred J. Provan. He was a son of the minister.

Fred Provan gave an unpleasant description of his dad. Later, summarizing for her husband and church trustees, Mrs. Comstock said that the young man described his father, the minister, as "a brute."

They had heard enough. One of the trustees, Andrew R. Bennett, a fifty-three-year-old former mayor, trekked at the end of May 1909 to Mineville, about 160 miles east through the Adirondacks, to find out the truth. It was an eye-opening trip. He learned for one thing that the minister Provan had recently spent some vacation days to answer charges brought by the presbytery in Mineville. The Reverend Provan had been asked to resign because of his relationship with Mrs. Berwick. Wilfred's tattling was enough for the Mineville people to reject their preacher. The $300 "gift" from Mineville was actually a settlement to get him out of town, Mr. Bennett learned.

This testimony was sufficient for trustees back in Philadelphia. They asked their minister to resign. He would be locked out of his church, he was told, and no, another $300 payoff from another disenchanted congregation was not to be his.

He was granted a hearing, however. He came with an attorney, but the church folk would have nothing to do with the barrister. Affidavits were read from people in Mineville as the minister sat mum. Then came the crowd's reaction. One man suggested tarring and feathering, but the fifty-two present voted unanimously for more humane treatment. Simply said, they fired him.

"The Provan home," the *Times* reported, "then became more of a dungeon than ever."

The long-silent Mrs. Provan finally could take it no longer. She would later tell of the suffering she had endured for many months, perhaps years, including numerous beatings at her husband's hand and being kept "a slave and in absolute silence and subjection." She had been forbidden to correspond with her children who had moved away, to answer the door or to meet any visitors at the house.

"If Mr. Provan ever came into my room," she told a *Times* reporter,

> *it was with some unkind word, some threat or to catch me writing to some of my children. He would come in my room again and again and not utter a word. He would look at me and then begin an examination that would include the inspection of the bureau drawers and of every piece of paper he could find. Other times when he would come in he would tell me what the people were saying of me, or he would call me some awful names and ask the curses of God upon my head.*

And he told her that she was not a fit mother. Four years earlier, he had given away their six-year-old daughter, Frances, without her knowledge, she said. To the day of her liberation, she had no idea where to find the child.

Now, in July 1909, she feared for her life. She sent word by Annie that she needed help. Her rescue was carried out.

The reverend, having completed his business affairs at the clerk's office, returned to the parsonage to find the front door locked. Entering by a side door, he found that his wife was gone. He soon confirmed his suspicion that she might be in hiding at the Comstock house. He was denied a visit with her.

"I'll give you just one minute to get off these premises," the retired lawmaker warned, according to the *Times* article. "If you don't, I'll have you under arrest. The district attorney's office has this matter in charge and a warrant will be put on you at once."

"For what?" the preacher challenged.

"For abusing your wife," he was advised.

Reverend Provan retreated, soon to board a train for Clayton. From there, it was suspected that he took a train to Montreal, where it was believed he rejoined Mrs. Berwick, who had earlier taken flight.

Mrs. Provan—the *Times* account never gave her first name—eventually left Philadelphia to live with one of her sons. Dr. and Mrs. Matthew M. Ryan offered to adopt Lyman, her youngest, but she declined, asserting, "He is my child and I shall never let him go."

She apparently backed away from that commitment. The 1943 obituary of Dr. Ryan listed among his survivors an adopted son, "Lyman Ryan of New York."

As for the Reverend Provan, ordained a Presbyterian minister, any record of him disappeared after 1909, according to Presbyterian archives.

Trees later grew where parishioners once stood in the Congregational church. The building was signed over to the Philadelphia Fire Department in August 1974 and was subsequently leveled.

AN AFFAIR TO REMEMBER

A doctor and a suicidal woman of ill repute put Watertown in the national spotlight. "Shall I shoot myself?" asked a twenty-year-old "lady of the night" as she pointed a revolver at her chest.

Looking her in the eye, a Watertown physician responded, "I don't care whether you do or not."

Cassie Hill pulled the trigger twice. No shots fired. Again, her finger squeezed the trigger. The percussion propelled a .22-caliber ball spinning through her left breast.

Five days later, on December 2, 1892, Cassie Hill died.

The talk about town—about Dr. Gordon P. Spencer's involvement in this episode in the "disorderly house" at number 4 Lepper Street—must have been furious enough. But that was small talk once the *National Police Gazette* took notice of the happening.

An illustration on the *Gazette*'s Christmas Eve front page gave readers across the nation's forty-four states a taste of the embarrassment that had slapped a prominent Watertown family. The story that ran on an inside page was less flamboyant than the cover. Occupying fewer than four inches of a typical newspaper column, the eight-paragraph account was under the appropriate heading, "Shall I Shoot Myself?"

Gordon Spencer, a thirty-one-year-old bachelor, was a third-generation physician and one of three Spencers practicing medicine in Watertown at the time. His seventy-one-year-old father, Dr. Henry Gordon Percival Spencer, was still practicing surgery. In fact, he was so active that two years later, he would bolt from the medical staff at the House of the Good Samaritan and spearhead the movement to open a hospital to be operated by the Catholic Sisters of Mercy.

The *National Police Gazette* illustration, appearing December 24, 1892. *Files of the* Watertown Daily Times.

Gordon's brother James, forty-three, was also a prominent surgeon.

Gordon was named for his grandfather, a Connecticut-born physician who had settled in Champion after tending the wounded at the Battle of Sackets Harbor in 1813.

Born in the family home on Watertown's Stone Street, Gordon Spencer obtained his medical education at Bellevue Hospital Medical College in New York. He established an office in Watertown's Iron Block building, above the Conde Hardware store.

Gordon was considered a kindhearted and charitable physician, the *Times* would say twenty-four years later on the occasion of his death. "Many stories are told of his good deeds towards needy patients."

But there was nothing considered kind about him after that shooting early on Monday, November 28, 1892, even if Cassie Hill was a woman of "shameful existence," as the *Times* so bluntly labeled her.

She was born Catherine Leighton on Christmas Day 1872 on a farm in the Binghamton area.

In the days following her death, the story of Cassie's life was told by the *Times*. A few years earlier, her sister, Jesse, had become involved with a traveling man, and the girls' father accused the man of keeping Jesse in hiding. He threatened to shoot the man, and Jesse and Catherine (Cassie) left home, going to Wilkes Barre, Pennsylvania. There, they settled in a "disorderly house."

While Jesse remained in Wilkes Barre, Cassie returned to New York, but she bypassed her home and ended up in Syracuse, where she found another "disorderly house." There, in October 1890, she met Mrs. Amey Clayton.

Mrs. Clayton subsequently moved to Watertown, setting up her "establishment" on Lepper Street, a short drive running between Coffeen and Newell Streets dotted by a few homes. Located at the corner of Lepper and Newell was the Elwood Brothers Silk Mill.

Cassie followed Mrs. Clayton in August 1891, taking up residence in the Lepper Street house.

She was "a remarkably beautiful young girl when she started out on her disgraceful career," the *Times* reported.

> [She] *possessed a pretty figure,* [was] *handsome in face and attractive and congenial. She had a rich head of flowing black hair, bluish gray eyes, which were large and sparkling, a full round face and clearcut features, and weighed about 138 pounds.*

The account continued, "Like other girls of her type, Cassie smoked cigarettes and soon acquired the habit of drinking. She loved beer and evil associations."

Early in the fall of 1892, she received word that her sister was seriously ill, and she set out for Wilkes Barre to pay a visit. When she got to Syracuse, the *Times* reported, "she met some women of her kind and they, with her appetite for drink, led her into a prolonged debauch."

She eventually reached Binghamton and learned that her sister had died. Her parents refused to receive Jesse's body, and Cassie returned to Watertown.

"She had been morose at times ever since, and it is believed that remorse and the consciousness that whiskey and cigarettes and morphine were fast completing the wreck of her life led to the fatal act," the *Times* reported.

November had opened with a historic national election. On November 8, Grover Cleveland became the first and only president of the United States to be sent back to the White House after having skipped a turn. The voters deposed the incumbent, Benjamin Harrison.

By the end of the month, the public in Watertown was in the dark about the bizarre event on Lepper Street.

"The affair was hushed up, and the outside world knew nothing of the occurrence until the poor girl's lips were sealed in death," the *Times* complained.

The event began harmlessly enough on Sunday, with Cassie going for a ride with "a friend," who was not initially identified. The couple made a stop at an establishment on the Sackets Harbor Road and then went to a hotel in Brownville. They returned at about midnight to the Lepper Street house, where supposedly they "retired" at about 2:00 a.m. on Monday. Cassie, it was reported, was "somewhat under the influence of liquor."

At 2:20 a.m., a gunshot rang out. Charles Adams, a laborer residing at 1 Lepper Street across the road, set the time a few days later at an inquest. "I am kept up nights by noises made around there by fellows. I heard a pistol shot about 2:20 a.m. I knew that was the time because I looked at my clock."

Dr. Spencer's name initially appeared only as the woman's attending physician. He summoned his brother, and then his father, for consultations in the case. Only later, during the inquest on December 5, was it revealed that Dr. Gordon Spencer was more than her doctor. He was the only witness—he was the "friend."

Curiously, the *Times* on December 6 did not highlight the doctor's involvement. Not until about midway into a lengthy story did the writer and editors include his eyewitness account.

"She made no statement that she was going to do it," he testified.

> *She asked me if she should shoot herself. Having examined the revolver* [previously], *when it was empty, and thinking it was empty, I said I did not care. I had previously removed cartridges from the revolver, put them in the cartridge box and counted them. But without my knowledge she had slipped one in.*

He said that he "attended her constantly."
He continued:

> *I had no idea that she was going to shoot herself. She went to see if her revolver was in the bureau drawer. It was there. She insisted on loading the barrel and I didn't want her to. During the scuffle she dropped the box of cartridges on the floor. I picked them all up and counted them, so that I knew that they were all there.*

Then came the shocking admission.

"She held the revolver close to her breast and said, 'Shall I shoot myself?' Having examined the revolver and thinking that it was harmless I said, 'I don't care whether you do or not.'"

Holding the gun to her left breast, "she snapped the revolver three times before it went off," he said. "She was standing at the foot of the bed with her hand resting on the foot board. She fell on the bed."

Cassie owned the pistol, he said.

Dr. Spencer ran downstairs, alerting Mrs. Clayton to the shooting, and then departed to summon his brother. Mrs. Clayton and three other occupants of the house—her sister, Myrtle Stafford; Bernice Gardner; and a traveling salesman, Robert Merrill, twenty-eight—rushed to the upper-level room.

Mrs. Clayton testified that she found Cassie lying on the bed, partially covered with her nightclothes.

"I asked her what was the matter and she said she had shot herself," Mrs. Clayton said.

She added that Cassie told her that she did it because of "lots of little things" and not because of any quarrel.

Mr. Merrill echoed the account. "She said that she had made a bad job of it, and that if she got well she would finish it."

The three doctors attended to Cassie, and four days later, she seemed to be recovering.

"Yesterday, she was up and about the house, drank wine and smoked cigarettes," the *Times* reported on Friday. "Late last night she became delirious and she died this morning."

Only then, five days later, were Watertown police chief Charles G. Champlin and District Attorney Frank H. Peck notified.

"The case was kept as quiet as possible and the *Times* man obtained the facts with difficulty," the *Times* reported.

Two doctors, M. Lee Smith and M.D. Smith, performed an autopsy and found that the bullet had passed through the edge of the liver, through the stomach and diaphragm and lodged within an eighth of an inch of the spinal column.

Dr. James Spencer said at the inquest that he found powder marks surrounding the bullet hole in her left breast and on the victim's index finger and thumb of the right hand.

There was no question that the wound was self-inflicted. The coroner's jury decided, however, that Cassie's death was not a suicide.

"The death which followed was from congestion of the lungs and heart complications," the *Times* reported. Cassie died from pneumonia.

No charges were filed against Dr. Gordon Spencer.

As they had done with her sister in Wilkes Barre, Cassie's parents and relatives refused to take her body "and left it to be cared for by the people with whom she had lived and sinned," the *Times* reported.

A funeral was conducted by a Methodist minister at the Clayton house, with the body placed in "a costly pink covered casket," according to the *Times*. There were four bearers: a bartender and "three men who live in disorderly houses."

A procession of the hearse and ten carriages transporting nineteen residents "of disorderly houses" found its way to a cemetery vault.

Shortly thereafter, Cassie's parents had a change of heart. They sent a telegram asking that her body be transported to Binghamton.

Gordon Spencer was married on October 3, 1894, to Jessie Van Brunt of Watertown, but their union ended in divorce about two years later. He later lived in his childhood home on Stone Street with his sister, Ada Myers. After she moved to Brooklyn, Dr. Spencer took a room in May 1915 at the YMCA.

On the morning of January 5, 1916, he was found dead of an apparent heart attack in his room. He had only $500 to his name, having likely been victimized, along with other family members, by his brother-in-law. Ephraim H. Myers, Ada's husband, was president of the First National Bank in Carthage when, in 1898, he embezzled bank funds and family investments and fled the area.

The *National Police Gazette* account of the shooting carried quotes from the fateful Spencer-Hill conversation that had not appeared in the *Watertown Daily Times*. Before asking if she should shoot herself, the *Gazette* reported that Cassie had said, "You do not love me, do you, Gordon?"

He was reported to have replied, "No, Cassie, I do not like you when you drink, and I have often told you so."

A transcript of the inquest testimony could not be found at the Jefferson County clerk's office to verify the validity of those quotes.

I acknowledge the assistance of the Jefferson County Surrogate Court, the office of Jefferson County historian James W. Ranger and Watertown city clerk and historian Donna M. Dutton. I used for a reference the July 2006 issue of the Hunter-Rice Health Science Library Samaritan Medical Center newsletter.

TRUST AND BETRAYAL
The Carthage Bank Scandal

If Allen E. Kilby felt a chill, it was from more than the January air as he listened to his friend and business partner. The lawyer and vice-president of Carthage's First National Bank had been summoned to the North Washington Street home of bank president Ephraim H. Myers. As they met face to face on this 1898 evening, Mr. Myers told his guest that he had gotten himself "in a tight place." He said that examiners would be paying a visit to the bank, which was headquartered in an attractive eleven- or twelve-year-old four-story stone and red brick building at State and Mechanic Streets. And surely, he predicted, they were about to discover that funds were missing. He admitted that he had juggled deposits and books to walk away with some money.

"I was stunned at the disclosure," the fifty-five-year-old Mr. Kilby told a reporter.

> *I did not stay long enough to get an answer to the question "why?" I wanted to get away. It could hardly seem real that Myers, the man whom all the community trusted, could have laid his hands on property which was not his own.*

Later that night, Mr. Kilby called an emergency meeting of the bank directors in his home. The bank president came too.

"He begged and he cried," Mr. Kilby told his interviewer from the *Sunday Herald* of Syracuse. "He said that if we would give him another chance he would retrieve his reputation. He would earn money and make it good."

The directors, with the examiners' blessings, covered up the scandal. Why ruin the respected Mr. Myers, a former Carthage village president, and at the same time risk injury to the bank, they reasoned.

Three months later, on April 26, 1898, the day after the United States declared war against Spain, Ephraim Myers took $6,700 from the bank's coffers, boarded a train and left for parts unknown, abandoning his wife, four teenage daughters and adult son. Never again would he be seen in Jefferson County. Reports eventually placed him in Cuba.

His associates and in-laws were left holding the bag for notes that they had underwritten for him. And the cash loss from his defalcation was found to be much more significant than the $6,700 he carried away that day. About $100,000—by today's standards, more than $2 million, according to Consumer Price Index statistics—had been embezzled over an eight-year period.

The First National Bank, located in what the *Geographical Gazetteer of Jefferson County*, edited by William H. Horton, described in 1890 as "one of the finest and most complete banking buildings in Northern New York, with all the modern improvements, including a fine vault and one of the strongest and best-made burglar-proof safes, with time clock," came crashing down at the hands of one man. The building survived and today stands renovated, thanks to the community's rescue mission.

Ephraim Myers was a native of Oneida County, where he was brought up by an aunt. He attended a business college in Syracuse and then ventured north to pursue a career.

He married Ada Antoinette Spencer, a daughter of a prominent Watertown couple, Dr. and Mrs. Henry G.P. Spencer. The newlyweds settled in Carthage about 1871. Their first child, Henry, was named after Ada's father, complete with the middle names Gordon Percival, just like his grandfather. Then arrived a daughter, Antoinette, in 1880; another girl, Ada, in 1882; and still two more girls, Frances and Bessie.

Just as this family was beginning to grow, the First National Bank appeared on the scene. With capital of $50,000, it was organized on New Year's Day 1880. After fire swept through 157 Carthage buildings on October 20, 1884, the bank's directors, in 1886, purchased a corner lot at State and Mechanic Streets and erected the prominent building for their bank, according to the *Gazetteer*.

At the time of the *Gazetteer's* publication in 1890, Mr. Myers was bank president, Mr. Kilby was vice-president and Allen G. Peck, thirty-two, was cashier.

Meanwhile, Mr. Myers was accumulating some property. While settling his family at Main and North Washington Streets, he picked up a piece of

An artist's sketch of Ephraim H. Myers. *Files of the* Watertown Daily Times, *originally appeared in the* Syracuse Herald.

land on Jefferson Street in January 1888 and then got quite busy in 1890. In February, he purchased a $2,000 house on West Street. Two months later, on what is now West End Avenue, he bought a plot bordered on the north and south by Brown and Furnace Streets. Then, in a foreclosure proceeding in August on behalf of his bank, he was both auctioneer and buyer of residential land on the north side of Fulton Street, extending from Clinton Street to James Street.

He was still speculating two years later. In partnership with Mr. Kilby and Marcus P. Mason, at fifty-seven a successful manufacturer in the village, Mr. Myers became an owner of the former Branaugh Tannery on West End Avenue. The group's investment was a tidy $14,400.

Any successful businessman was certainly due his recreational escape. For Mr. Myers, summer fun was had on the St. Lawrence River. In 1889, he signed ninety-nine-year leases for not one, but three lots at Round Island Park, near Clayton. In the fall of 1890, he leased half of another lot on the island, with his associate, Mr. Kilby, leasing the other half.

Mr. Myers took a stab at politics in 1891, winning election to a one-year term as village president. That term was apparently sufficiently satisfying to him and his constituents, who returned him to office for one more year.

"His habits were good, inexpensive and beyond criticism," and he "was regarded as a keen, thorough business man," a lengthy investigative story reported on May 2, 1898, in the *Sunday Herald*. His dabbling in real estate, both locally and out West, "paid him well," the newspaper said. He also converted his fondness for showy and expensive horses into a profitable venture, making clever deals in buying and selling horses.

But not everything he touched turned to gold. His wife told the newspaper that he had lost a considerable amount in an investment in a manufacturing plant and in patent rights. The bank, meanwhile, appeared to be a successful venture. The original $50,000 capital had doubled, the institution was paying dividends and its stock was paying 7 percent annually.

Another financial institution, Carthage Savings Bank, shared space under the roof of the First National Bank. And cozy neighbors they were. For instance, First National's cashier, Mr. Peck, was treasurer next door at Carthage Savings.

"He was the only man available for that business," Mr. Kilby explained. "We felt that the interests of the bank demanded that we should keep him."

Mr. Myers would eventually take advantage of the two institutions' relationship.

The bank president's financial affairs appear to have taken a downturn late in 1897. On December 14, according to court documents filed in the

Jefferson County clerk's office, he took the train to Watertown and made an unexpected visit to the office of his father-in-law, who, at seventy-six and in declining health, was still marginally carrying on his gynecology practice.

A kindly man, Dr. Spencer agreed to endorse a $2,000 note for Mr. Myers at First National, with payment promised in three months. Two weeks later, Ephraim and Ada Myers signed a $5,000 promissory note with the bank, payable in six months, and used their Round Island Park leases as collateral.

Then came the two house meetings on the night of January 20, 1898. Mr. Myers told his associates that he was short $2,000 in his account with the bank and that he had taken funds from the bank and appropriated the money to his own use.

The following day, a bank examiner found a bigger hole in "peculiar transactions" between Carthage Savings and First National—$20,000 was missing. Mr. Myers acknowledged that he was at fault, and at the examiner's insistence, he signed another note promising payback.

Bank trustees, holding hope that they could still trust their troubled colleague, signed on as guarantors. Placing their money and stockholdings at risk were his wife Ada; his mother-in-law, Emily Spencer, sixty-eight; Mr. Kilby; Mr. Mason; Christian M. Rohr, forty-six, a farmer; Addison L. Clark, fifty-four, a banker and insurance man; Foster Penniman, seventy-four, a hotel keeper; and Martin Rugg, seventy-nine, a well-to-do shoemaker.

Under the agreement, Mr. Myers was to immediately be removed as president. But that did not happen. The trustees allowed him to remain until they could find a replacement.

Later in the month, he was granted an extension on a $4,700 mortgage. He would have until the end of July to pay it off.

The extended tenure granted by the trustees enabled Mr. Myers to do more creative bookkeeping. Depositors handed money over to him, unaware that the accounting he made on bank records was far less than what he noted on the customers' savings books. He didn't bother with the small deposits; the large depositors—businessmen—were his targets.

He was familiar with their routines, and he made sure that he was there to "assist" them. As mid-March arrived, he had not satisfied the loan that Dr. Spencer had cosigned. The doctor was obligated to pay $2,063 to close that account.

Finally, any hope for First National Bank unraveled on Tuesday, April 26. Mr. Myers arrived at the bank at about his usual time. He pocketed $6,700 and wrote a letter, leaving it on his desk. He would have liked to stay and work out the problems he had created, he said, but the looks on

the trustees' faces at a recent meeting made it clear that he was no longer of any use to them.

"I might as well go away and die as to stay and bear the agony," he wrote.

To facilitate the examination, he promised to give a note for the unknown amount that he owed the bank. This, he erroneously suggested, would perhaps give the directors an opportunity to get along without having a receiver appointed.

His note concluded that no one had participated in the matter but himself, and no one had benefited from it.

Telling co-workers that he was going to Watertown on business and would return Wednesday, he walked down Mechanic Street to the train station and boarded a car with his wife. The couple parted company in Watertown's New York Central Railroad Depot, each to attend to his or her particular interests.

Mr. Myers went to see his father-in-law, who then accompanied him back to the depot.

Dr. Spencer thought that Mr. Myers was returning to Carthage, but suddenly Mr. Myers "guessed that he would go to Syracuse on business," the doctor later noted in a court document.

Parting company with the doctor, Mr. Myers boarded the Carthage train to meet Ada.

"He told me he would have to stay overnight in Watertown, and he alighted from the train. He said he had business with Jim in the morning," Mrs. Myers told the *Sunday Herald*.

Jim—Ada's brother, Dr. James D. Spencer—did not see his brother-in-law.

The next day, a letter written by the embezzler was mailed from Syracuse to Emily Spencer, "informing her that he did not know when he would return and did not know that he should ever return," Mr. Myers's father-in-law said in his affidavit.

Mrs. Myers told the *Herald* reporter that she had no idea where her husband went and hoped that he would return home "and face his trouble like a man." In subsequent court filings, she expressed her belief that he had left the country to escape prosecution.

In the days that followed Mr. Myers's disappearance, discoveries of more missing money, by the thousands, prompted Mr. Kilby to suggest that his lost friend had hidden money away over the years with full intentions of making himself rich and "he is now well provided with the result of his stealings."

One year later to the month, like father like son, Henry G.P. Myers, a partner in the Fulton Chain Lumber Co., absconded with some of his company's books and documents "and is supposed to have joined his

The Buckley Building remains a landmark in Carthage. *Courtesy of the* Watertown Daily Times.

sire in that undiscovered country to which the latter fled," a newspaper account read.

The First National Bank was closed immediately, never to reopen. Foreclosures were imposed on the Myers properties and the Round Island leases—"said property will not sell for over $2,500," said a legal filing.

Mrs. Myers became the target of victims and accusers. Marcus Mason, for one, came to her house demanding that she hand over whatever money her husband had left to support her. Several lawsuits, naming Dr. Spencer, bank trustees, Mr. Myers and his wife, were filed. Dr. Spencer similarly filed suit against the missing man in a futile effort to recover the money that he had spent to bail out his son-in-law.

Legal haggling was still in progress a year later when Dr. Spencer traveled to Minneapolis for treatment. There, on June 27, 1899, he died.

"His kindness was as great as his courage," a *Times* obituary writer said. "In his latter years Dr. Spencer has had many troubles and afflictions that would

have crushed at once a weaker man, but always he has endured misfortune with strength and fortitude and dignity."

His widow followed him to their Brookside Cemetery grave four years later.

Foster Penniman also died during the height of litigation. A former two-term Wilna town supervisor who had operated a hotel in the town for ten years, he was seventy-five when he died on November 14, 1899.

After losing her home in the forfeiture proceedings, Ada Myers moved back to the Spencer family colonial home in Watertown at 17 Stone Street—later 155 Stone Street—and then relocated to Brooklyn in about 1916. She died on August 7, 1932. Her obituary's only reference to Ephraim Myers was that she was his widow.

The last reference found regarding her children is the obituary of Frances Myers Campbell in March 1966.

Allen Kilby, who had served two years in the state assembly prior to the First National Bank debacle, continued his law practice in Carthage. He lived to be eighty, dying on April 4, 1922.

Allen Peck, the cashier, managed to climb from the bank's ashes to become a successful businessman. He was instrumental in organizing the Carthage Electric Co., owning a share of the business for several years. He also opened Carthage Supply Co., a wholesaler in paper products. Still active in the company at seventy-seven, he was rushing to catch the noon train to Watertown on March 16, 1936, when he collapsed on Church Street, dying of a heart attack.

Addison Clark, who also served in the assembly, later helped organize Copenhagen National Bank. He conducted an insurance agency in Copenhagen, where he was village president and school board president. He died at age ninety in 1933.

Martin Rugg, who had marketed groceries, along with the boots and shoes he made, was recognized as one of Carthage's wealthiest residents when he died in January 1902.

Mr. Mason was a Carthage success story. Drawn to the village by a friend, he came with $200 in his pocket and began a business of manufacturing broomsticks. With his father, he formed the company H. Mason & Son. They bought a sawmill and manufactured wood pumps with iron fixtures. He later made map mountings that he sold throughout the country for twenty-five years.

Mr. Mason also built a knitting mill in 1873 and took over an underwear factory and converted it into a hosiery manufacture plant. Elected the first president of West Carthage in 1889, he was the seventy-four-year-old president of Northern Bag & Plate Co. in Carthage when he died in October 1909.

Tales of "Times Gone By"

The National Bank building was sold in January 1900 to brothers Rufus J. and S. Brown Richardson, dealers of agriculture products and cheese in Lewis County. The National Exchange Bank of Carthage moved its headquarters across the street in 1930.

William A. Buckley, a real estate broker, bought the building in 1944, and although the structure changed hands a number of times, it has since existed as the Buckley Building.

In December 1945, an early morning fire erupted in a third-floor apartment of the Buckley Building, forcing the resident, Clara Lederle, seventy-one, to flee to the street in her nightclothes.

I have several contributors to acknowledge for this story. First and foremost is Carthage historian Laura Prievo, who brought it to our attention. Times *librarian Esther Daniels assisted with research. Helping hands were provided by Jefferson County historian Benjamin J. Cobb, Watertown city clerk and historian Donna Dutton, the genealogy department of Flower Memorial Library, the Jefferson County Surrogate Court and the Brookside Cemetery Association.*

A FINANCIAL FORTRESS

Bank Withstood the Panic of 1893

Watertown police chief Miles Guest stood on a table, trying to bring order to the anxious crowd of jostling men and women. To calm the panicked crowd, the state's governor, Roswell P. Flower, stood at the doorway of the little bank at Stone and Washington Streets and made "the best speech he ever made," the *Albany Argus* reported.

Even a parish priest, the Reverend Tobias Glenn, held fast near the teller's counter, preaching the attributes of the thirty-four-year-old Jefferson County Savings Bank. The bank was under siege on this warm Thursday, the sixth day of July 1893.

Could these three men and a few other prominent Watertown citizens save their bank? Or would the run on the bank bring it down, along with the 425 other lending institutions across the nation that collapsed in the face of the Panic of 1893?

Since the bank was able to move into attractive new quarters in 1923 and would operate under the same name into 1973—"County" got dropped along the way—we can proclaim "yes" in response to the former question and "no" to the latter. But for one day, there were many doubters.

It was a busy time of year for the bank, since semiannual payments on a 4 percent interest rate were being made, the *Watertown Daily* times reported. On such "paydays" as this, it was usual for a greater than normal number of clients to show up, ready to check out their earnings.

But there were a number of depositors from out of town, farmers here to carry on their business and stock up on supplies. A gathering of so many people at the bank was certain to arouse some suspicion, some concern, for the visitors. After all, the seeds of panic had already been planted. Two

The Jefferson County Savings Bank occupied this building on the southwest corner of Washington and Stone Streets in Watertown from 1884 to 1994. *Files of the* Watertown Daily Times.

industry giants, the Philadelphia and Reading Railway Co. and the National Cordage Co., had filed for bankruptcy in February and May, respectively. Suddenly, the stability of banks was being tested.

"People were very wary of banks by the late nineteenth-century, unless they were rich enough to own part of a bank," said William P. Hills of Watertown, author of *Banking On It: A Century of Northern New York Banking*.

"Distrust was so deep-seated," Mr. Hills said. "Every family had a story about losing their savings in a bank where deposits were not insured, so they were ready to take their money back."

Tales of "Times Gone By"

They had been stung by financial collapses in 1873 and 1884.

And now, in 1893, the American economy under the administration of President Grover Cleveland had become vulnerable, with speculation in overseas investment and artificial inflation of the silver-based money supply. When the government's substandard gold reserve became exposed by Treasury Department action in April, the rush was on.

The bank had been open for an hour when, at about 10:00 a.m., excitement built to a fever pitch. People were three abreast trying to cross a threshold that was barely suitable for two. The *Times* described the scene:

> *Stylish young clerks, bearded and brown-faced working men and nervous women crowded and jostled each other to advance themselves a step nearer the cashier's window. The air became heated and close, and those standing nearest the paying counter were dripping with perspiration.*
>
> *Dudes forgot their wilting linen and the curl disappeared from the hair of usually pretty girls, hanging like rat-tails over their shiny foreheads. Elderly women, who on the street passed each other with dignified bows, shoved and scrambled for the nearest place, digging their elbows into their neighbors' ribs and clutching the counter as a drowning man grasps at a straw.*

There were several fights, "and the contest became so exciting between one man and a woman that the latter brought her stout umbrella into play and won the advantage by pounding him in the face."

One "large fleshy Irish woman" fought for naught, said the newspaper account. She pulled from her pocket what she had thought to be her bankbook, but it was actually her grocery book.

"That won't do," said the teller, A. TenEyck Lansing.

"Devil, not a cint hov I now," said she, expecting the bank to come tumbling down.

Soon, prodding his way through the crowd, came Chief Guest. He moved a long table a few feet from the teller's window, restricting the flow of people to a more uniform line.

Of equal concern to the policeman was the unsavory lot possibly waiting outside for an unsuspecting lady or gentleman tucking away his or her fresh cash. The *Times* warned:

> *The county has villains who would cut a throat, burn a building or put a bullet through a human heart for a few hundred dollars. If the money in the banks in Jefferson County was drawn out tomorrow bandits like Jesse James and Oliver Curtis Perry would abandon the dangerous business of*

robbing express trains and make a vigorous raid on the farms and working men of Jefferson County who have their earnings hid in bed ticks or in bureau drawers, old trunks and tin boxes.

Governor Flower, in the midst of his only term as the state's chief executive, was in his hometown at the time. Positioning himself prominently at the bank, he addressed all who would listen. He spoke of the bank's president, Talcott H. Camp, and its other officers. "There is not one of them," he said, "whom I would not trust to invest money for me. They never speculate and are prudent men."

And he counseled about the stakes raised by a panicky public:

You by your actions force the banks to keep a larger amount on hand than usual. To get this money the bank officials have to refuse to loan money on mortgages and also refuse to loan it on commercial paper, and therefore you restrict trade and thereby throw labor out of employment.

As he continued, he minced few words. "In demanding money which you do not want, you are forcing the foreclosures of mortgages and driving men from their homes," the governor charged.

Word of the downtown uproar spread fast, with other areas of the state, and perhaps beyond, getting news from Associated Press and United Press dispatches. The *Albany Argus* told its readers:

Governor Flower has spent much more time on many of his prepared addresses and has doubtless given more thought to them than to these blunt extempore words in the middle of an excited throng of men and women. But it is the best speech he ever made.

Father Glenn, the pastor at St. Patrick's Church, spent much of the afternoon doing his share for the bank. Passing out printed slips of a bank statement, he espoused the "absolute safety" of deposits, the *Times* reported. "His influence sent many away contented."

And there were other protectors not named. Some purposely arrived to make deposits, while others "took pity on several elderly women" and wrote them personal guarantees of payment should their banked money evaporate, the paper reported.

One Irishman reached teller Lansing, ready to take home his money, and then had a change of heart, as witnessed by the newspaper's reporter.

"Kin I dthraw moy money?" the man asked.

"Certainly," replied Mr. Lansing.

"Thin I don't want it," the customer said, bravely walking away.

The clock showed five minutes left in this busiest of busy bank days.

"Ladies and gentlemen," announced Chief Guest, "this bank will close at four o'clock. There are five minutes more."

Sweaty faces at the rear of the line gave glances of despair and anger. One woman, advanced in her years, abandoned her position, stepped out of the bank, sat down on the steps and "indulged in copious tears," the reporter wrote.

The cashier, she insisted, had paid out money as slowly as possible to deprive depositors of their savings.

Mr. Hill noted that Mr. Lansing was likely figuring interest rates on paper. The bank probably had that relatively new invention, the adding machine, but…"they didn't trust adding machines, and didn't want to be seen using adding machines," Mr. Hill said.

At 4:03 p.m., the thirty-eight-year-old Mr. Lansing administered the final withdrawal and then, as the reporter observed, "drew a sigh of relief as he rested himself against the counter." He remained there for a few more minutes, assuring turned-away customers that the bank would reopen as usual on Friday at 9:00 a.m. And it did, without a renewal of Thursday's frenzy.

Meanwhile, the dust having settled, a final accounting of the run does not seem so disruptive by today's standards. Withdrawals totaled little more than $10,000, which were cushioned by deposits of about $8,000.

Bank officers reported that they had $397,615 on hand when the doors opened and claimed they still would have had a quarter of a million dollars tucked away, even if every depositor's every dollar had been withdrawn.

Officers of Jefferson County Savings Bank showed no compassion to those who had displayed their distrust of the facility. "The trustees have decided to refuse to accept a return of money withdrawn during the panic," the July 8 issue of the *Times* reported.

> *They do not care for a repetition of the annoyance and unnecessary anxiety caused by those who were so foolishly frightened on Thursday, and they say that people who have no confidence in the institution are not desirable depositors.*

Some of Father Glenn's parishioners faced an added dilemma, as was shown two days later in the following account:

Key players in defusing the run on the bank were, from the left, Watertown police chief Miles Guest, banker A. TenEyck Lansing, Governor Roswell P. Flower and the Reverend Tobias Glenn, pastor of St. Patrick's Church. *Courtesy of the* Watertown Daily Times *and the Jefferson County Historical Society.*

Rev. Father Glenn was present during the run, using his influence to stop it, when he discovered that many of his flock who were supposed to be poor had snug little bank accounts. At the services in St. Patrick's Church yesterday he announced that he would pass around for the usual 10 cents collection for the benefit of the new orphans' home on Coffeen Street. He said he hoped each and every one would give the small sum of 10 cents for this benefit.

In closing his appeal for money, he said, "I am now in possession of facts that show me that many of you are not so destitute as I had heretofore reason to believe, and in the future I shall expect the contributions to be larger than they have been in the past."

The besieged teller, Abraham TenEyck Lansing, made the Jefferson County Savings Bank his career, but then, why shouldn't he have? His grandfather, George C. Sherman, was a founder of the bank in 1859, according to Mr. Lansing's 1937 obituary. Mr. Lansing was associated with the bank for fifty-eight years and served as president from 1909 to 1916. His great-grandfather, Noadiah Hubbard, was the county's first Caucasian settler, and his grandmother, Mary Hubbard, was said to have been the first Caucasian girl born in the county.

Watertown was a village of fewer than eight thousand people when, in 1859, the savings bank opened for business in a back room of a store in the Hotel Woodruff. The facility expanded its space with a move, in 1861, to the basement of a building at the northwest corner of Washington and Stone Streets (where HSBC now stands) and then finally acquired a more

prominent home just across Stone Street in 1884, purchasing the former Northern Insurance Company building (where Key Bank now stands). It was here that the bank endured the run of 1893. The year after the run, that building and a neighboring structure were leveled to make way for a new, six-story edifice, which served as Jefferson County Savings Bank for twenty-nine years. The building was sold to Jefferson County National Bank, and next door was erected what was said to be "one of the finest savings bank homes in the state." The new bank, what is now Community Bank, opened on May 7, 1923, and was "a monument to Mr. Lansing's career…for it represents the materialization of his hopes," said his obituary.

Jefferson Savings Bank disappeared as an entity in 1973, when a merger made it Community Savings Bank. Eleven years later, Community Savings became part of Lincoln First Bank, which in turn fell into the Chase-Manhattan system.

In 1995, the building was restored its former name, with Chase-Manhattan transferring ownership to Community Bank Systems Inc.

Resources regarding the Panic of 1893 were found at the Princeton Economic Institute–International History Department on the Internet. Times librarian Esther Daniels assisted with research.

A CIVIL WAR FATHER AND SON
KILLED BY THE SAME SHELL

T he scene may have looked like this: An eighteen-year-old Union soldier sits near the wreckage of the battle at Fredericksburg, Virginia, with tears welling in his eyes, writing the crushing news to his mother back in Jefferson County that his father is dead. Not only that, but so is his brother.

The writer was Nelson W. Randall. Both John Z. Randall, forty-seven, and Artemus A. Randall, twenty, had been felled by a Confederate-fired shell—the same shell.

The War Between the States was in its twentieth month when President Abraham Lincoln's army suffered a convincing and discouraging defeat on December 13, 1862, at Fredericksburg. The battle left many weeping widows and mothers. Among them was thirty-eight-year-old Almena Randall of Woods Mills in the town of Wilna. With the three men in her family gone to war, two of them now dead, she was managing the family farm and tending to her thirteen- and three-year-old daughters.

There is little record to be found of Mrs. Randall, but county census records indicate that she must have stood strong despite her losses.

The migration of New Englanders into the woods of northern New York in the late eighteenth century brought a Vermont couple to settle in Herkimer County. William Randall and his wife had five children, the second of whom was also named William. The junior William married Amanda Ross, who would bring eleven children into the world.

One of the eleven was John Zinah Randall, born May 17, 1815. When John was twenty-five, he married Almena Brooks, who was about sixteen when they exchanged vows on November 17, 1840. Their firstborn son,

Artemus Asahel Randall, born March 3, 1842, was named for one of John's brothers, who had died in infancy.

Nelson was born on February 22, 1844, and five years later, on March 11, 1849, the couple's first daughter, Esther, arrived.

This Randall family made Woods Mills their home in March 1852, when John spent $340 for a plot of land along the Indian River that he bought from John G. Hubbard, husband of one of his older sisters, Clarina.

Mr. Randall expanded his property with acquisitions in 1853 and 1855, putting together a 150-acre farm on which he was producing twenty-five bushels of wheat, forty bushels of oats, seven bushels of corn and forty pounds of wool, according to the county's 1860 census. He had three horses, six cows, two pigs and four "other cattle," which were probably sheep for wool.

Almena, meanwhile, added a new member to the family on July 27, 1859, in the person of Ella A. Randall. Ella would be just shy of three months old when, hundreds of miles away from this isolated, tiny, rural community, an incident occurred that would indirectly shape her future. On October 17, 1859, a band of eighteen abolitionists and their leader, John Brown, overtook an arsenal at Harpers Ferry, Virginia, as a means of encouraging slaves to rebel. Brown was captured the next day and was later hanged for treason.

A nation already at odds over slavery was drawn closer to conflict. The rift widened toward the inevitable in December 1860, when South Carolina seceded from the Union, leading the way to a new Confederate States of America. Confederate troops attacked Fort Sumter in the harbor of Charleston, South Carolina, on April 12, 1861. Three days later, President Lincoln issued a call to loyal states for troops.

Loyalists in the north country were quick to respond. One unit that began to form the very next month was the Thirty-fifth New York Volunteer Infantry Regiment. Young men signed up with various companies of the new regiment in Watertown, Copenhagen, Adams, Redwood, Brownville and Theresa, where Company C was formed.

On September 27, Nelson Randall, then seventeen, committed himself to the cause in Theresa. Two days later, his older brother, Artemus, followed suit. By then, the regiment had already gone to Washington and was joining the Army of the Potomac.

From August 16 to September 2, 1862, the Jefferson County regiment participated in General John Pope's campaign in Virginia, seeing action in battles at Rappahannock River, Sulphur Springs, Gainesville, Groveton, Bull Run and Fairfax Courthouse.

John Randall. *Courtesy of Judith Maclean, Olympia, Washington.*

On September 1, 1862, ten days before the regiment entered the bloody Antietam campaign, John Z. Randall followed his sons to war. "He was a most brave and noble man, whose patriotism alone induced him to take up arms," the *Carthage Republican* would later report.

Confederate troops retreated in defeat from Antietam on September 17. Sharing in a taste of victory, the Thirty-fifth Regiment set off en route to the command of General Ambrose E. Burnside. Destination: Fredericksburg.

A correspondent for the *New York Reformer*, calling himself "Budlong," set the stage for readers in Watertown:

> *You can imagine our position by supposing that the rebels had 100 cannons planted on the hills south of Watertown, and that our army had crossed Black River, and were obliged to engage those batteries; and as we progressed up the river, new and hidden pieces were brought to bear upon us from the bluffs and from the woods in front.*

Almena Randall.
*Courtesy of Judith
Maclean, Olympia,
Washington.*

On the morning of December 10, General Burnside began a daylong assault with his artillery. By day's end, three pontoon bridges had been placed, and Union soldiers entered the flaming city of Fredericksburg. Some Confederate resistance the following day failed to tarnish the apparent Union victory.

Then came Saturday morning, December 13, 1862. Budlong wrote:

About 6 o'clock, after having sufficient time for eating our breakfast, the troops commenced deploying and by 9 o'clock had taken the position assigned them. So thorough was General Burnside's plan of battle that not only every division but every brigade had been assigned a position. At 8 o'clock the order was given to advance and the long lines of infantry, as far as the eye could reach, moved majestically forward. Instantly the whole hills shook and the earth trembled as the rebel batteries spoke from hill tops, where 50 cannons commanded us to pause.

Union artillery and cavalry maneuvered to support the infantry.

We moved up and down our lines, ready to support the weakest points, in full view and in range of the enemy's guns. The majority of their shells passed over our heads, but occasionally bursting in our ranks, removing one or two files. Men were struck while removing the wounded from the field. Generals and colonels were killed and aids [sic] were hurled to the earth, such was the carnage of battle. The majority of the officers pronounced this cannonading as heavy and galling as any they have witnessed.

The men of the Thirty-fifth showed their courage, Budlong wrote.

Scarcely any anxiety was manifested, so intent was every one upon obeying orders and remaining firm in their places. When shells burst in Co. A and C, the men nearest the unfortunate only turned their heads to behold the fate of their companions.

At about 3:00 p.m., the soldiers of the Thirty-fifth were ordered to lie down to try to avoid the continuing barrage of Confederate shells, Nelson Randall said in his letter home. The *Carthage Republican*, using Nelson's letter, reported:

While lying there, a shell struck John Z. Randall on the left shoulder and tore his body asunder, killing him instantly. The same shell struck his son Artemas [sic] and carried away his right leg at the knee and tore the flesh from the left, above the knee.

Artemus Randall died the next day.

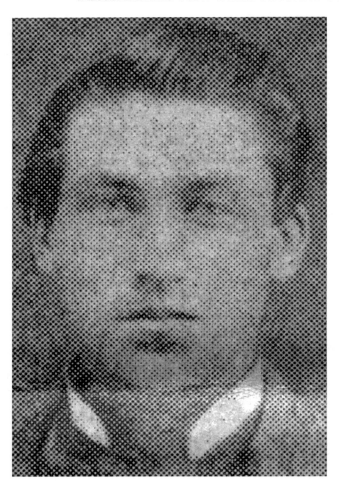

Artemus Randall.
Courtesy of Judith Maclean, Olympia, Washington.

The toll paid by the Union army that weekend was 1,180 dead and 2,145 missing. There were 9,028 wounded. For the victorious Confederates, 579 were dead, 127 missing and 3,870 wounded.

Despite the slaughter, the Thirty-fifth actually got out of the battle relatively intact, according to a history of the unit written in 1887. "Their position there, upon the extreme left of the line, where there was little infantry engagement, saved them from the awful slaughter of the right and center."

Six of the unit's members were killed; two more died later, including Artemus, and fifteen were wounded.

Nelson Randall apparently was among the wounded. He was mustered out of his unit on January 24, 1863, listed as disabled.

The Thirty-fifth was subjected to no more combat. The unit took up winter quarters on the Potomac and then was assigned to provost duty along the Aquia Creek and Fredericksburg Railroad until May 1863, when its service ended.

The Randall father and son were given temporary battlefield burials. Their remains were later returned home for permanent interment, but exactly where they were buried is puzzling. There are monuments standing for them in both Sandy Hollow Cemetery in Philadelphia and in Woods Mills Cemetery, which is now a part of Fort Drum.

"They fought for their country, noble and brave, on the battlefield of Fredericksburg, they fought to save," their Sandy Hollow monument reads.

The farm that Almena Randall continued to operate despite the loss of her husband and son apparently grew, although modestly. The 1865 county census shows that three acres had been added to the property, and the number of cows being milked had more than doubled to thirteen by 1864, yielding 2,572 gallons of milk.

Almena had two horses, three swine and four chickens. Her land was giving her 25 tons of hay, 15 bushels of corn, 75 bushels of oats and 115 bushels of potatoes. She made 450 pounds of maple sugar from the sap of her maple trees.

On Christmas Eve 1868, Almena began a new life, marrying William K. Peck. In doing so, she likely forfeited her war widow's pension, which even in her day may not have been much of a sacrifice. Such pensions have been found to range from two to eighteen dollars annually. Since her husband had been a private, she was on the lower end of the benefit scale.

But she kept her property and added to it in 1870, purchasing the holdings of her surviving son and his wife of three years, the former Ellen P. Smith.

Almena Randall Peck outlived her second son. Nelson moved to Nyack, where for eight years he operated a molding mill. He then relocated to Hoboken, New Jersey, where he purchased a planing mill. On December 22, 1892, at the age of forty-eight, he was killed by machinery in his factory.

Mrs. Peck died on June 1, 1896. Her youngest child, Ella, who was married in 1885 to Silas Monroe, moved to Seattle, Washington, where she died on November 21, 1923.

The last survivor from the John and Almena Randall family was Esther, who on October 25, 1870, became the wife of William H. Ormiston. The couple had a son, who may have been named for Esther's brother Artemus, and a daughter, Ruth, who became the wife of Wilson J. Hastings.

The only descendants of John and Almena Randall still living in the north country, to my determination, are from the line of Ruth Ormiston Hastings.

Nelson Randall. *Courtesy of Judith Maclean, Olympia, Washington.*

Of her four children (she also named a son Artemus), her son Ernest became the father of Dewey K. Hastings, a resident of Ogdensburg. Mr. Hastings's daughter, Wanda Livingston, the great-great-great-granddaughter of the Civil War couple, also lives in Ogdensburg.

Gathering information about a nineteenth-century farmer is no easy task, especially when he was not active politically. I gratefully acknowledge the valued assistance of Harold I. Sanderson, author of Whispers from the Past: A Source Book of Civil War Veterans from Jefferson County; *town of Wilna historian Laura M. Prievo; Benjamin J. Cobb, county records management coordinator; Judith Maclean, a great-great-granddaughter of John and Almena who lives in Olympia, Washington; and Esther I. Daniels,* Times *librarian.*

Tales of "Times Gone By"

Files in the Jefferson County Surrogate Court and material compiled by Rensselaer A. Oakes in his 1905 Genealogical and Family History, County of Jefferson *also proved most useful. Mr. Oakes, a Watertown newspaperman and magazine writer, died at age sixty-nine in April 1904, several months before his history was published.*

A variety of source material interchangeably spelled the dead Civil War son's name as Artemus and Artemas. The family's recent genealogy, compiled by Judith Maclean, has him as Artemas, but Mr. Oakes spelled it Artemus.

During her search through microfilm for newspaper reports about the Battle of Fredericksburg, Mrs. Daniels came across an item that appeared on Christmas Day 1862 in the Jefferson County Union*: "The following report of the killed, wounded and missing in the 94th Regiment has been forwarded to us by Lieut. Charles E. Hulbert, Acting Adjutant: Killed—Co. A, A.A. Larkins, shot in the breast; David Shampine, shot in the head."*

The latter war victim was nineteen. Any relation to me? I have no idea!

A CIVIL WAR HERO MISSED HIS CHANCE TO CHANGE HISTORY

Where was "Grampa Jack" of Smithville when President Lincoln needed him most? After all, only seventeen months earlier the one-armed soldier, by his own account, had shielded the president from would-be assassins. But on that fateful evening of April 14, 1865, Ford's Theatre in Washington was out of sight and out of mind for the newlywed officer.

Grampa Jack, as some of his descendants in southern Jefferson County call him, was Major Frederick R. Jackson, veteran of the Seventh Connecticut Volunteers in the Union army and winner of the prestigious Medal of Honor. He lived in Smithville, but not until many years after he was wounded on a Civil War battlefield and many years after he walked and chatted with the sixteenth president of the United States.

So, who was this Major Jackson? He is prominent enough to have had a bridge named for him in 1991 in North Haven, Connecticut. He was born there on February 18, 1844, a son of Benjamin Hall and Harriet Bradley Jackson. He must have been an intelligent young man because at the age of seventeen, he was all set to enter Yale.

And permit me a bit of pride here if I boast that he was a newspaper reporter. That is what Walter Gawrych, first selectman of North Haven in 1989, wrote for the *Quadtown Advisor*, a community newspaper.

When the conflict over states' rights came along, the young Mr. Jackson was determined to join the fight to preserve the Union. He came from fighting and patriotic stock, his obituary reveals. In 1638, his ancestors came to the New World and became members of the New Haven, Connecticut settlement. In the next century, when the colonies fought to break away from

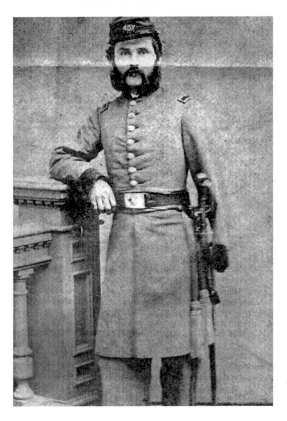

After losing his left arm in battle, Civil War soldier Frederick R. Jackson was held as a prisoner of war. *Courtesy of Joyce Crumb, Adams, New York.*

British rule, among the volunteers in the freedom fight were two men who would someday be his grandfathers.

Mr. Jackson enlisted in July 1861. A life-altering incident took place on June 16, 1862, when he was an eighteen-year-old first sergeant. He was at James Island in South Carolina.

The brief explanation for his Medal of Honor describes what happened: "Having his left arm shot away in a charge on the enemy, he continued on duty, taking part in a second and a third charge until he fell exhausted from the loss of blood."

We turn to his obituary, which appeared on February 18, 1925, in the *Watertown Daily Times*, for an expanded account.

> *He was struck on the elbow…and his arm was severely shattered. With his other hand he seized the splintered arm and pressed it tightly to his side to prevent as far as possible the flow of blood. He plunged again into the battle and his regiment, after repeated charges, retired. When the troops*

were finally repulsed, [he] *fell from loss of blood and lay on the battlefield amid intense firing for 17 hours before he finally was taken prisoner by the rebel forces and removed to a hospital.*

He was taken to meet the surgeon's knife, the story continues. "He was one of 14 soldiers taken to the amputating room of the hospital, and there his arm was amputated without the use of chloroform."

The soldier was kept prisoner until October 12, 1862, according to records at the National Archives in Washington. A week later, as he was being discharged from the army, he met the president, who had been informed by other soldiers of Mr. Jackson's heroics and his injury.

In a letter written by Mr. Jackson nearly three decades later, he quoted the president.

"I want to give this brave boy a Medal of Honor, and I wish you would personally see that he has one," Mr. Lincoln said to Secretary of War Edwin M. Stanton. Then, dismissing the soldier, Mr. Lincoln promised him a commission.

Mr. Jackson returned to Connecticut, much to the surprise of his mother, who had received word from the Department of War that he had been killed in action.

The wounded warrior was nineteen when he received, in the fall of 1863, the commission the president had promised, along with Mr. Lincoln's invitation to Washington. He went to the War Department, and there he had an unexpected meeting with the president.

"He recognized me and stopped and talked with me. In a few moments he said abruptly, 'By the way, you have got your Medal of Honor all right, I suppose?'"

But he had not.

"Then he asked me to go with him and took me straight to Secretary Stanton's room and said 'Our little lieutenant says he hasn't received his Medal of Honor yet. Did you send it to him?'"

Mr. Stanton confirmed that he had not and fulfilled the command two weeks later.

Now we approach the time where documented history and the soldier's accounts fail to concur. What is correctly recorded is that Mr. Lincoln selected the one-armed soldier to command his honor guard for his trip to Gettysburg for the November 19, 1863 dedication of the national cemetery there. But Lincoln historians both in Gettysburg and in Illinois, "the Land of Lincoln," say that they are unaware of the Jackson version of what happened while the president and his guard detail were en route to the famed delivery of the Gettysburg Address.

It was November 18, 1863, the day before Abraham Lincoln would pull a piece of paper from his pocket and read, "Four score and seven years ago…"

We refer to a story from an unidentified newspaper, which quoted Mr. Jackson extensively:

> *It was well that the great war president had a guard on that occasion, for an attempt was made in Baltimore by a gang of roughs to get into his car. I had 50 men on the train as a guard. We arrived in Baltimore early in the morning, and as the cars were being slowly hauled by horses through the city, the crowd jumped upon the platform of the private car in which sat Lincoln and Stanton. It was a silent crowd that received us as the train rolled into the depot, just such a crowd as would be bent on making trouble.*
>
> *We tried to get the fellows off the platform, but they persisted and packed on like sardines. I at last ordered my men to use the bayonet and we pricked several of them before they would jump down.*
>
> *Secretary Stanton always claimed that those fellows were bent on assassinating the president and that only my guard saved him.*

The *Baltimore Sun* checked its archives for me and found a story about the president passing through that day, but it did not find anything describing the skirmish on the train. A story in the *Sun* listed Lieutenant F.R. Jackson in command of the First Invalid Regiment honor guard on the train.

"There was quite a crowd of persons at the Camden Station upon the arrival of the train, and the President was repeatedly cheered," the story said. Mr. Lincoln "came to the platform of the car in which he was several times and acknowledged the cheering, and at the same time gave every one a chance to have a good look at him."

The story did disclose, however, "much sport and a great amount of crowding was indulged in to obtain a sight of the distinguished passengers."

There could have been more to the "crowding" than what was reported, according to John Heiser, historian at the Gettysburg National Military Park. "If there were any attempts such as described [by Mr. Jackson], they were not written about in newspapers of the day and the reporting of any events such as this may have been suppressed by the Pinkerton agents," Mr. Heiser said.

A letter written by Major Jackson in 1894, reprinted in a book, *The Badge of Gallantry*, by Lieutenant Colonel Joseph B. Mitchell, addressed a different war topic, but it may offer some answers to any questions about his veracity. "I never sought fame, honor or notoriety," he said. "I don't care to tell of my own deeds. I always dreaded to. It seemed so egotistical."

Tales of "Times Gone By"

More service lay ahead for the one-armed officer. He was put in charge of Fort Kearney, one of the Northern defenses for the divided nation's capital. Here he stood his ground for five days and five hours, his two companies countering the July 1864 attack of Confederate General Jubal A. Early. It could have been a blood bath if General Early had known how superior his numbers were to those of the Union defenders. But he fought conservatively and then had to pull back when Union reinforcements arrived.

During that waning period of the war, Jackson developed a fellowship with the president, as related in the unidentified newspaper's story:

> *When in command of the war department grounds, it was my custom to escort the president nearly every night. He would come over to the war department early in the evening and I would return with him to the White House at any hour between 10 o'clock and 4 in the morning. Secretary Stanton would have me buckle on my sword belt and revolver and would send me off with the president. Lincoln wanted no guards, but the war secretary insisted that he was in personal danger if he did not have some protection.*

Mr. Jackson also talked about the president's "very mischievous son" Tad and of often finding that the boy had fallen asleep in Mr. Lincoln's office while awaiting the statesman's late-night return.

While in Washington, Lieutenant Jackson married Emma Lakin and took her home to North Haven. It was during that leave of absence that Mr. Lincoln was felled by a bullet to the head.

"I took the first train for Washington and upon my arrival Mr. Stanton assigned me to the charge of forming the escort of officers who were to march in the procession," he said in the newspaper story.

Mr. Jackson resigned on May 22, 1865, as a twenty-one-year-old major.

His descendants are unsure about when Mr. Jackson became a New Yorker. His wife was only twenty-six when she died, and that was in 1872 in Connecticut. The 1894 letter quoted in *The Badge of Gallantry* was written on stationery of the Dewey House, Thousand Islands, and was mailed in Clayton, but he wrote a return address in New Haven.

Emma Jackson bore two daughters. One lived in Washington, and the other, Maude, was married in New Haven to a Yale student, Grant Erastus Crumb of Clayton, in 1885. Mr. Crumb returned to Clayton with his bride, eventually moving to Chaumont and finally to Smithville. Major Jackson was with them in Smithville for his last years of life. He is buried at Smithville Cemetery in a modestly marked grave.

Grant E. Crumb died in 1927, and Maude died in December 1953.

When Cary R. Brick, then the chief of staff for Representative John M. McHugh (R–Pierrepont Manor), went to the National Archives to assist me in this war story, he came up with another interesting note about the old soldier. Major Jackson had to convince Washington that he had been awarded the Medal of Honor.

In a November 5, 1892 letter, Mr. Jackson wrote from New Haven, "It is with the greatest surprise that I have just learned…that my name did not appear" on a list of medal winners. In the letter, he described how Mr. Lincoln had directed Mr. Stanton to issue him the award.

The War Department responded within days, disclosing that "no record has been found that a Medal of Honor was granted you." He was asked to send the medal to Washington as evidence of his claim while officials researched his military records.

He complied with the request. It seems astounding that Washington acted so quickly. In a letter dated November 28, 1892, Mr. Jackson was informed that his "name has been properly noted on the records of this Department in accordance with the facts stated in the inscription on the Medal of Honor," and the medal was returned to him.

The whereabouts of his medal are unknown to his descendants in Jefferson County. It may be with family in California. Or is it where it belongs—with his remains?

Material for this story was provided by Hilda Hayes of Smithville and Joyce Crumb of Adams, widows of the major's great-grandsons Wenzell Hayes and Grant Edwin Crumb. The major's great-granddaughter Virginia Crumb and great-great-grandchildren Emily Hayes, Joyce Hayes and Wenzell Hayes Jr. also assisted. The unidentified newspaper, saved by Emily Hayes, may have been the National Tribune, *official newspaper of the Grand Army of the Republic, according to Mr. Heiser in Gettysburg.*

Post on the Plains

M ore than a century ago, a community convinced Congress that it was the best place to open a military base. "Why do we want the soldiers up there?" Jere Coughlin, publisher of the *Watertown Herald*, answered his own editorial question: "Because they have money to spend." But he was skeptical of what lay ahead.

> *Cover this land with men, and what about fevers and foraging and hundreds of soldier tricks not mentioned in the military rules? Would not the rest of the people be paying pretty dearly for the trade the merchants and the railroad would get?*
>
> *"Soldiers are not all devils," you say. Sure; and they are not all saints, by the same token.*

He expressed this viewpoint as the army, at the direction of President Theodore Roosevelt, was looking at Pine Plains in Jefferson County as a potential "concentration camp" for military training.

> *If the Chamber of Commerce...and all the rest of the camp boomers, would organize and use their brains and their energy to reforest that 9,000 acres, it would be far more beneficial to the people hereabouts than a soldiers' camp and bring fame and fortunes to the generation that will succeed us.*

Mr. Coughlin's voice was a whisper in a wave of popular opinion. Pine Plains, a territory in the form of an equilateral triangle about eight miles long and three to four miles wide, was soon to become the core of what is

Colonel Philip Reade. *Courtesy of Robert Brennan, Sackets Harbor, New York.*

today's Fort Drum, the much larger and more utilized home of the Tenth Mountain Division.

The *New York Times* broke the story on May 15, 1906. President Roosevelt was seeking appropriations from Congress for six camps across the nation. The army needed open country, which, the president insisted, is the best place to teach men exactly what they should do in times of war.

Five sites had already been selected, in the states of Washington, Wyoming, Texas, Indiana and Georgia, the *Times* reported. The sixth should be in New York, military planners determined, but "there is a lot of trouble ahead," the paper continued. Five sites were under review, and all seemed to present problems.

The army was looking at a location near Albany. Northville, in the state forest reservation, was another place of interest, as was Montauk Point in Suffolk County. Plattsburgh and "a strip of land known as Pine Plains, near Watertown" completed the list, the *Times* reported.

Of the latter two, the *Times* noted, "it is not thought that either of these places will be selected."

This undated photo was labeled "Soldiers arriving and departing at Pine Camp Station." *Fort Drum historical collection.*

The *New York Times* could not foresee the community effort that would gain momentum in the days ahead, nor would it recognize the efforts of a persuasive sixty-one-year-old command officer at Madison Barracks in Sackets Harbor—Colonel Philip Reade of the Twenty-third Infantry.

A day after the *New York Times* report, the *Watertown Daily Times* caught up with Colonel Reade.

"He was well known about town and his familiar figure, clad in his field uniform and wearing his big hat, was seen very much here," the local paper reported a few years later. "His quick nervous stride spoke of the potential energy stored up in the man and his love for something doing."

The colonel had come to Madison Barracks with the Twenty-third Infantry, having been given command of the unit in Cuba after distinguishing himself "for coolness and gallantry under fire" in the Battle of San Juan Hill during the Spanish-American War.

His career dated back to the Civil War. The native of Lowell, Massachusetts, was in a cadet school in his home state when the War Between the States broke out. He was too young to enlist, but he ventured to the Midwest and began, on his own initiative, doing "secret service expeditions" that provided valuable information to the Union army.

New York governor Charles E. Hughes and General Frederick D. Grant, commander of the camp, met during the governor's inspection of Pine Camp. *Fort Drum historical collection.*

Impressed by the young man's efforts, a general gave his command officers orders "to pass without hindrance this especial youth on special service," the *Watertown Times* reported.

His exploits won the favor of President Abraham Lincoln, who appointed him a cadet at large at West Point. He was commissioned a second lieutenant in 1867. In the next twenty-four years, Reade would

fight the Cheyennes in Kansas; intervene in racial tensions in Louisiana; hang telegraph lines from Santa Fe to San Diego and in Wyoming; instruct state militias in Wisconsin, Illinois, Minnesota, Iowa and Michigan; and trail renegade Sioux in the Dakotas.

On the very day that the *New York Times* revealed that the government was looking at Pine Plains, Colonel Reade was doing just that, accompanied by two of his officers. He told the *Watertown Daily Times* the next day that the region could offer many advantages as a camp for a large body of soldiers. There is plenty of ground and no swamps or mosquito infestation, he said. Easy access from railroads was another plus, he added.

All three sides of the triangle were approachable from lines of the New York Central Railroad, so troops could disembark at Great Bend, Felts Mills, Evans Mills, Black River and Sterlingville, the *Watertown Times* reported.

All he needed to do, Colonel Reade said, was prove the existence of an ample and healthy water supply.

The *Times* assured its readers, "It is well known that plenty of water is available on the Plains." There are streams and springs in the vicinity, the newspaper reported, and "it is believed by many that driven wells would find a large quantity of pure sand-filtered water."

And there were more attributes touted by the *Times*. The terrain "is diversified with hillocks, large level spaces and a few patches of wood," a writer said.

> *It lies high and dry, and is practically unoccupied, except around the outskirts, and nothing in the shape of farming is carried on and no crops raised, so military maneuvers would not incur any damage. The land is of little value and a great part of it is unclaimed by anyone.*

Another call to attention came in May, when a goal was announced to establish the camp "this summer," to open July 15 for a three-month training session for five to ten thousand men. Three regular army infantry regiments, including Reade's Twenty-third, three batteries of a siege artillery, two companies of engineers, a signal corps and a hospital corps would be coming here—or somewhere in the state—to be instructed in the skills of battle. So, too, would be the militias from Maine, New Hampshire, Vermont, Massachusetts, Rhode Island, New York, Connecticut, Pennsylvania, Delaware, Maryland and the District of Columbia.

General Frederick D. Grant, commander of the Department of the East and son of President Ulysses S. Grant, was to be the commander of the camp.

The community's reaction was almost immediate. For one, the railroad's general traffic manager committed to offering the government the best of facilities. And some property owners in the vicinity offered to donate land, the *Times* reported.

The Watertown Chamber of Commerce announced on June 1 the formation of a special committee to persuade the War Department to select Pine Plains. The chamber asked its members for individual contributions of no more than $5 to establish a campaign fund of $300.

Committee members included attorneys John N. Carlisle and George H. Cobb; David M. Anderson, president of Taggart's Paper Co.; Nathaniel P. Wardwell, cashier at Watertown National Bank; James S. Boyer, clerk with Agricultural Insurance Co.; James H. Hustis, superintendent with New York Central Railroad; Frank A. Hinds, civil engineer; Lewis W. Day, wholesale grocer; Samuel F. Bagg, secretary of Watertown Steam Engine Works; James R. Miller, clothier; Willard D. McKinstry, president of the Brockway Co., publisher of the *Watertown Daily Times*; and Edward N. Smith.

A statement was drafted enumerating the many advantages of Pine Plains and urging War Department representatives to come and see it for themselves.

Later in May, Colonel Reade reported that he was satisfied that there was an abundance of pure water. Competent chemists had found the water to be of superior quality, he said.

The colonel was convinced that no other site in the state could offer the advantages of Pine Plains: ample space and land that was high and dry, with long level stretches for maneuvers and woods sufficient for camping.

June passed and so did July. Training season was at hand, but no plans were in place. Not until October did the War Department's inspection materialize.

At 9:30 a.m. on October 16, a train with a special car for the inspection team rolled into Watertown. A general and ten officers of various ranks, accompanied by a railroad official, were greeted by a committee consisting of Colonel Reade, two officers of the New York National Guard, state senator George H. Cobb and other civilian officials.

A morning briefing was held at the state armory at 190 Arsenal Street. The railroad provided maps and photos of the region and expressed a willingness to do everything reasonable in the way of constructing switches, siding, platforms and providing other necessary equipment. National Guard major John N. Carlisle gave a presentation on the various studies regarding topography, drainage, water supply and railroad facilities. When one of the visiting officers suggested that Pine Plains was not big enough, Major Carlisle countered that there were assurances that

Tales of "Times Gone By"

Mule teams at the Pine Camp freight yard. *Fort Drum historical collection.*

additional land was readily available at a reasonable price, averaging ten dollars per acre.

Jesse M. Adams, an analyst with C.C. Herrick & Co., discussed the soil formation, the presence of springs, drainage and water purity.

Following lunch at the Woodruff House, the army officers boarded the train for trips to Carthage and Philadelphia and made stops to inspect some of the Pine Plains terrain. The party left the next day, offering no comment about its findings.

The president and his War Department asked Congress to appropriate $700,000 for the proposed camps. Congress tightened its purse strings. No money was allotted, but the following year, confirmation for the Pine Plains appropriation was received.

Pine Plains had won over some military minds. General James H. Lloyd, commander of the Third brigade of the New York National Guard, led a team back to Watertown in May 1907 to lay out plans for National Guard training. Late in August, with General Lloyd in command, camp streets were established on the plains, tents were pitched and freight railroading in the region was suspended to give the right of way to troop trains.

On August 31, 1907, military training debuted at an encampment "just out on the eastern edge of the great unfenced and barren plain, about a mile back from the little village of Felts Mills," the *Times* reported. It was temporarily named Camp Hughes for the governor of New York, George

E. Hughes. The session was for only a week, but it set the groundwork for maneuvers on the plains for decades to come.

In 1935, the largest peacetime maneuvers ever conducted up to that time were staged at Pine Plains, involving 36,500 soldiers from throughout the Northeast. Four years later, with a wary eye on a war in Europe, the United States stepped up its use of the plains, then called Pine Camp, for the training of newly formed divisions. To accommodate its needs here, the government, in 1941, purchased more than seventy thousand acres of farmland, sending about five hundred families packing and committing to history the communities of North Wilna, Nauvoo, Sterlingville and LeRaysville.

Another name change—to Camp Drum—came in 1951, a salute to Lieutenant General Hugh A. Drum, commander of the First Army during World War II. Camp Drum was designated Fort Drum in 1974. On September 11, 1984, it was announced that the post would become the headquarters for the Tenth Light Infantry Division, now the Tenth Mountain Division.

Colonel Reade was transferred from Madison Barracks in January 1908 and was, a short time later, promoted by President Roosevelt to brigadier general. Since he was scheduled for retirement in October, he felt privileged.

"A promotion of this kind is a compliment," he said to a reporter in Syracuse. "I appreciate it."

He died in 1919.

I salute Robert E. Brennan, of Sackets Harbor, who researched the material presented in this story. Assistance was also obtained from James D. Neville, former curator of the Fort Drum and Tenth Mountain Division Historical Collection.

HEARTACHE ON THE HOMEFRONT

M abel Sampson Churchill was fifteen at the time, but about six decades later she still recalled vividly the day she and her dad went back to see their former home at Pine Plains. It was August 1941, and they had pulled up stakes near the ghost hamlet of North Wilna at the behest of the United States Army.

"They had blown apart the house and run it over with tanks," Mrs. Churchill, of Burrville, recalled of the melancholic day she shared with her father.

> *Dad held me in his arms and we cried, and not often did he cry. It was so awful. Nothing alive is what hit me the most. The echo of the winds making the creaking noise in the old barn where it seems our life depended on.*

They had seen enough.

"Girl, we have to go," said Dan B. Sampson. "Your mom's needing us."

Mabel climbed into her father's truck, and as he motored away, she cried silently, "looking back till I could no longer see."

This was near the end of the great exodus of some 525 families, when a $20 million expansion of what was then called Pine Camp—later Camp Drum and now Fort Drum—swallowed the hamlets of LeRaysville, Sterlingville, Woods Mills, Lewisburg, North Wilna and a place called Nauvoo. A compilation at the time by the late *Watertown Daily Times* reporter Boyd W. Moffett showed the eighty-four-thousand-acre federal land purchase closing six churches and twenty-four one- and two-room schools, displacing twenty-

"It was so awful," Mabel Sampson Churchill said of her family's eviction. *Courtesy of the Watertown Daily Times.*

six teachers and leveling the majority of about three thousand buildings scattered in close to one thousand separate land tracts.

In 1939, the army started targeting Pine Camp, with its 10,307 acres, as a site for expanded military training. The initial call was to purchase 7,585 acres, but that was just the first volley. The big economic news for Jefferson, Lewis and St. Lawrence Counties came in September 1940, when Lieutenant General Hugh A. Drum, First Army commander, recommended the additional purchase of 75,000 acres adjacent to Pine Camp. The reason for General Drum's recommendation became clear the following month.

"Pine Camp military reservation will become the center for a new streamlined army division of 15,000 men," a news story began. This news must have been as explosive as that of the November day forty-five years later when Fort Drum was designated the home of the Tenth Mountain Division.

Forty engineers arrived rapidly, beginning the survey for expansion and setting in motion the wheels for the last harvests of Pine Plains.

Residents gathered at a January 1941 meeting in Evans Mills to learn how they would be affected. Their apparent futility was perhaps best expressed by Helen Redmond of Evans Mills. "Well, if the Army wants the land, there isn't anything we could do about it," she said.

But another speaker offered a more patriotic approach. "I am 100 percent American, and I would rather have the United States government come in and take my land than Hitler or any bombs," said Arthur Dewey.

An editorial in the *Watertown Daily Times* the next day cautioned against greed or anti-expansion sentiments. "It is conceivable that any opposition can be extended to a point where the government will decide not to carry out its plans," the editorial warned.

> *This would be unfortunate indeed and would be a great disappointment to people of this county and of Northern New York generally. We do not mean by this that owners of land should be asked to sacrifice their properties, and such will not be necessary. But the government will not submit to dictation and it is conceivable that an excitement and an opposition can be aroused which will result in abandonment of the plan to extend the camp.*

Nevertheless, ninety-four people in the town of Philadelphia signed a petition that asked President Franklin D. Roosevelt to spare their properties from the expansion. But within the next two months, by May 1941, the government had acquired its first 1,027 acres for the buildup, and more than 300 of that acreage was in the town of Philadelphia—some was even within the village.

The army, meanwhile, tried to ease apprehension that people would be rushed to vacate their land. Major General Irving J. Phillipson, Second Corps commander, promised, "No one will be dispossessed suddenly, all acquisitions will be based on points where they will cause the least possible hardship to the people, and no injustice will be done."

Every issue, he said, "will receive my sympathetic consideration."

He also offered some prophetic words: "The Army industry will be one of the greatest things this section has known for 150 years. This will be a permanent industry...We are not destroying the past, but rather creating the future."

On Thanksgiving Day 1940, Dan Sampson broke the news to his family. The forty-eight-year-old farmer and his wife, Lila, thirty-seven, gathered their six boys and five girls together in their nineteenth-century two-story home.

"I've got something to tell you," the head of the family began. He told them of the letter he had received from the government.

"He was sick," Mrs. Churchill said, "and we cried constantly. Nobody wanted to move."

Don Sampson remembers that soldiers "did wonders for a kid." *Courtesy of the* Watertown Daily Times.

The families were not being thrown out in the cold to fend for themselves. On the contrary, New York State and the federal government assigned agencies to work with the people of Pine Plains to find new homes for them, to arrange fair sales prices and to provide transportation for moving.

The New York State Defense Relocation Corporation, created by the Farm Security Administration of the U.S. Department of Agriculture, opened an office at 110 Arsenal Street in Watertown. Another helper was Harry P. Brann, who moved from Potsdam to serve as director of the Pine Camp Land Acquisition Office.

"We have found these people a fine group with which to deal," Mr. Brann told a reporter. "They have responded to our requests in nearly every instance and in many cases have leaned over backwards to cooperate with us."

Many people moved early, but the majority, having waited for their crops to ripen, waited until Uncle Sam's patience shortened. Finally, the anticipated announcement came on August 30, 1941.

Tales of "Times Gone By"

"The War Department has announced that the Army must have possession of the expansion area by Monday, Sept. 1," a *Times* story reported. But an understanding federal hand was still being extended.

"Every consideration will be given to those families who have found it impossible to move by the deadline," the story continued. "They will be asked to complete arrangements for moving just as soon as possible and will be permitted to remain in their homes a reasonable length of time until these arrangements can be made."

That weekend, the nomads, the Sampson family included, hit the road. "A stream of trucks, tractors, hay wagons and private automobiles, each bearing farm implements and household goods, began pouring out of the area Monday," the *Times* reported. "The movement will increase in volume during the next three days, and on Saturday and Sunday it is anticipated the highways will be clogged with families moving to new homes."

Their destinations were scattered. Many went to Lewis County, and others to Adams, Mexico, Pulaski and Oswego. But some ventured farther away, to Auburn, Canandaigua and into the Mohawk Valley. A few ended up in St. Lawrence and Franklin Counties.

The Sampsons were the last to leave their neighborhood, since the feds found it a bit difficult to place a family of thirteen, with another on the way, according to Mrs. Churchill. When they moved out, the family was transplanted to Cook Road in the town of Rutland.

Three months later, Lila Sampson gave birth to her twelfth baby, a boy. Another girl was to be born four years down the road.

Before the move, however, the Sampson family had unexpected visitors to their condemned home. Three men in civilian clothes arrived early one morning and asked to take photographs.

"Dad didn't want it, and mom was terrified," Mrs. Churchill said. "But the men talked them into it. I cried and cried. I was wearing a housecoat and I said I didn't want my picture taken with me in a housecoat. A man said it was beautiful and made me stand there."

They didn't know that two photographers of national prominence were focusing on them. They never saw any of the pictures until recently, after a magazine, *Doubletake*, ran a photo above the caption, "The government took their land and then took their picture."

The photographers were Jack Delano and Arthur Rothstein, who crossed the nation making classic pictorial records of human suffering during war and in the Great Depression.

There is a bit of family lore about how the house and property came to be the Sampson home. It was a hand-me-down by adoption, so to speak.

Don Sampson and Mabel Churchill stand in front of the remains of their childhood home. *Courtesy of Mabel Churchill, Burrville, New York.*

As the story goes, according to Mrs. Churchill, a girl was born about 1845, probably in December, and for reasons that can only be imagined, the infant's mother felt compelled to give her baby away. So on Christmas morning in the year of the baby's birth, the little one was placed by the front door of, fittingly, the Christmas house.

Charles and Anna Christmas took the baby to be their own, naming her Jane. Charles and Anna were farmers, maintaining their home along what was called Buck Creek, on Flick Road near the Nauvoo School Road. Their piece of the world was northeast of Sterlingville and southeast of Philadelphia.

Jane Christmas lost her adoptive mother in 1878, and four years later her adoptive father died, according to a family history compiled by Suzanne M. Kiernan Smith, Mrs. Churchill's granddaughter. Jane and the man she married, Harrison J. Gates, assumed proprietorship of the Wilna farm, and she held it to the day she died, January 1, 1934.

Mr. and Mrs. Gates had three daughters, one of whom, Mae Bell Sampson, gave them two grandsons. One of the grandsons, Dan Sampson, became the last man to farm the plot.

The Sampson farm was stocked with nineteen cows "at most," Mrs. Churchill said, two horses, pigs, chickens and turkeys.

"We had white turkeys, eleven or thirteen of them," said her brother, Donald D. Sampson of Perch Lake Road.

Tales of "Times Gone By"

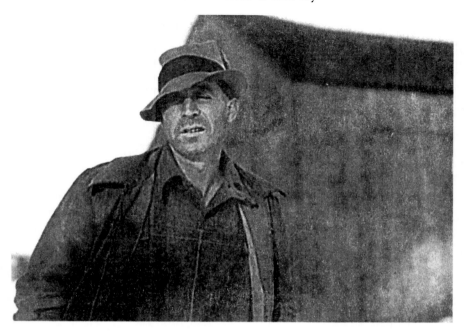

Daniel Sampson. *Courtesy of Arthur Rothstein, Library of Congress.*

I remember one Sunday, somebody stole them all. Mom went out and they were all gone. Dad told her, "Tomorrow morning, they'll be there." And he was right, they were. He knew who did it, and he paid them a little visit.

The Sampson boys had a bit of fun at the expense of their neighbors, as well. "We used to cut logs," Donald Sampson reminisced.

We'd cross Buck Creek on a flat rock section, where there was only a couple inches of water, then we'd skid out the logs on our doodle bug.
It ain't stealing, it's called making a living. It was hell making a living. Dad did everything that he could, cut wood and sell it by the cord, sell crops and milk. He had a thrashing machine and took it farm to farm helping all the other farmers.

There were nine farms in the area, Mrs. Churchill said, and all the families worked together to get their harvests in. "We wouldn't see dad for a week," she said.

Another of their father's income sources is something Mrs. Churchill was too embarrassed to mention, but brother Donald was none too shy about it.

"Dad had a still," he said. "He made moonshine. We had this huge pig, old Sally. This one day, she was acting funny and we thought she was dying. We ran up to the house and got dad."

Their father checked out the situation and came up with an answer: "She's drunk."

When the Sampson kids weren't milking cows or tending to other chores, playing, dipping in the Buck Creek swimming hole, fishing, swinging from beams in the barn, picking berries or getting into a little mischief here and there, they were attending the Reedville School.

"There were about twenty-seven kids, just enough to make a good fight," Don Sampson said.

A big treat for the kids, Mrs. Churchill said, was when their father went to Carthage or Antwerp and brought back cookies and bananas.

The army moved in before a lot of civilians moved out. "We could hardly go to school without meeting up with some soldiers," Mrs. Churchill said. "They were like flies."

Gunfire and maneuvers were all around their home, the siblings remembered. "The shooting didn't scare us," Don Sampson said. "We got used to it. Besides, we were pretty good daredevils."

The two remembered the time when "twenty-five or thirty soldiers on horses were in our front yard. Dad came out with a gun."

Fortunately, it did not develop into a combative situation. Actually, the army respected the family's property rights and left them alone. The soldiers "did wonders for a kid, showing off their tanks and stuff," Mr. Sampson said.

"We learned a lot of stuff in two years," his sister added.

The army was doing something else besides having war games before the family moved, something that survivors in the family believe has become their legacy.

"I can remember planes coming over," Mrs. Churchill said. "I thought they were spraying for black flies and mosquitoes. You could see the fog as they sprayed all over. Dad yelled at us, told us to get under cover or get in the house."

It was a misty white substance, she remembered, and gave off an odd odor. Berries and leaves curled up. Berries were no longer plentiful, and Mr. Sampson told his youngsters to avoid those that were tainted. Mrs. Churchill can't forget those sprayings when she thinks of how seven of her siblings died. They all had lung cancer, she said. Yes, she acknowledged, they were smokers.

The Sampson home. *Courtesy of Arthur Rothstein, Library of Congress.*

Was this spray Agent Orange, which was first tested during World War II? A Fort Drum spokesman said that there is nothing in historical records to indicate that Agent Orange was a "testing tool" at Camp Drum during the war. He said that pesticides may have been used "in a controlled environment" to kill plants.

The Sampson family consisted of:

William H. Sampson, who died of lung cancer on July 12, 1983, at age fifty-nine.

Warner Sampson, who died of a massive heart attack on March 20, 1980, at age fifty-four.

Mabel Churchill, born on March 7, 1926.

Dorothy Ferris, who died of lung cancer in 1985 at age fifty-seven.

Frank B. Sampson, who died of lung cancer in 1969.

Donald B. Sampson, born on March 23, 1930.

Charlotte Jackson, born on September 29, 1935.

Clara Slate, born on September 30, 1937.

John C. Sampson, who died of lung cancer in July 1976 at age forty-five.

Edward J. Sampson, who died of lung cancer on November 27, 1983, at age forty-seven.

Lila Shampine, who died of lung cancer on April 11, 2000, at age sixty-one.

Samuel Sampson, who died of lung cancer on December 24, 1975, at age thirty-four.

Gloria Dobson, born on September 14, 1945.

Their father, Dan B. Sampson, was born in Brooklyn on September 7, 1892. He was sixty-seven when he died on June 21, 1960. Their mother, Lila Vancor Sampson, was born on November 25, 1903, and died on December 11, 1960.

After the Pine Plains exodus, the following editorial appeared in September 1941 in the *Watertown Daily Times*:

A Sunday afternoon ride to LeRaysville, along the county road to Sterlingville and North Wilna, is awe-inspiring and impressive. Here is a land of rolling sandy hills with trim farm houses. It is deserted country today. The farmers have moved...It is a scene reminiscent of Bret Harte's writings of the freshly deserted mining country of Nevada and California. The fields and pastures are green from the heavy late summer rains. The trees are just assuming a touch of the color of autumn. But there is silence. The sun reflects upon empty windows. Barns which were full of hay and grain have been emptied. The Ayrshire herds of cattle have been driven away. In some places curtains have been left in the upstairs window or a broken mowing machine lies in the field. A baby carriage, out-grown possibly by a maturing youngster, remains on the porch.

This is the country through which James Sterling drew his ore for his Sterlingville furnace. This is the country which more than a century ago saw the lumbering carriages of the LeRays and others of French nobility pass on rutty, muddy roads. Today the people have left and the army takes over...A new day dawns for this interesting portion of Jefferson County.

Assistance in obtaining material for this story was provided by Roxanne Churchill Mustizer; Mark Holberg, Times *systems editor; Constance A. Holbert, media center clerk at Jefferson Community College; Benjamin J. Cobb, Jefferson County records management coordinator; and* Times *librarian Esther Daniels.*

A YARD OF DEATH

A telephone call interrupted Dr. Edward W. Jones as he treated a patient in his Woolworth Building office. His daughter, he was told, had been burned.

The forty-six-year-old physician asked his patient, Army Lieutenant George W. White of Madison Barracks, to accompany him to 423 Dimmick Street. As they arrived on that afternoon of July 12, 1922, the doctor and soldier eyed a "yard of death," as the *Watertown Daily Times* called it. They saw a crowd gathering, with people weeping at the sight of some dismembered bodies covered with building paper, sheets and blankets. Dr. Jones knelt beside one of the covered forms, raised the paper and then "uttered a cry of grief." It was the mutilated corpse of his nine-year-old daughter, Vivian.

Only by the small plaster that he had earlier placed over a bruise on her leg could the doctor recognize his daughter. Quickly, Dr. Jones summoned the strength to put his profession before his personal loss.

"Probably the coolest man in the accident was Dr. Jones," the *Times* reported. "He calmly assisted in identifying the children" and offered aid to other grief-stricken parents.

Finally, when there was nothing more that he could do or say, Dr. Jones, joined by the Reverend Joseph L. Cole, pastor of St. Patrick's Church, mournfully walked away from what had become—and remains—the largest single event of human tragedy ever to hit Watertown.

Eight children were dead, the victims of an exploded artillery shell.

"The American people are curious and are souvenir hunters," Jefferson County's district attorney, E. Robert Wilcox, said that day. "They will pick up almost anything and carry it home as a remembrance of some place or occasion."

An innocent Saturday family outing a year earlier, July 16, 1921, had set the stage for tragedy.

Edward G. Workman, a pattern maker for Bagley and Sewall Co., and his wife, Anna, took their son, Anson, and their upstairs neighbor, Jessie F. Salisbury, with her son, Munroe, on a berry-picking adventure near Great Bend. They found their harvest in the sandy terrain of Pine Camp.

As they wandered to a spot some two hundred feet from the road, Munroe, fifteen, called out to his companions to show off what he had stumbled upon. There, exposed on the ground, lay a twenty-two-inch-long artillery shell, six inches in diameter.

Anson, twelve, asked his father if they could keep it. Although it was no light device, weighing about one hundred pounds, Mr. Workman obligingly loaded it into his auto, and off to Watertown they carried it.

For the next 361½ days, on the back porch of the Workman-Salisbury home at 423 Dimmick Street, the shell remained undisturbed. Until, that is, one day perhaps less than a week before that fateful afternoon.

"I pushed it around on the porch a few days ago," Anna Workman later admitted, "to see if it would explode."

There was no fuse cap in it, her husband said, and he intended to use it as the base of a lamp. "We never considered the shell dangerous," Mr. Workman admitted.

Early July 1922 was typically hot and humid. Temperatures for three days had been in the eighties until Tuesday night, the eleventh day of the month, when relief came in the form of a "terrific thunder storm," the *Times* reported. The loud clatters of thunder and brilliant flashes of lightning ushered in gale-like winds and a torrent of rain.

After a half hour, the storm passed, leaving behind a refreshing drop in temperature to sixty-three degrees. But the following dawn brought a renewal to the warm spell. Under a bright early afternoon sun, the mercury had climbed back to eighty-six degrees.

Anson Workman began his day with a neighborhood friend, going into the woods to pick cherries. When he returned home, Ann Workman pressed her son to get dressed for a funeral in Depauville. The boy pleaded fatigue from cherry picking, asking that he be allowed to stay home. Mrs. Workman relented, leaving behind not only Anson but also his sister, Edna, two years his senior.

Munroe Salisbury wasn't supposed to be home. Now sixteen, he was a talented violinist who performed with the Clayton Park Orchestra. But he was homesick in Clayton, and against the wishes of the orchestra's manager, Munroe caught a train home that Wednesday morning. After getting off the train shortly before

The home at the "yard of death" on Dimmick Street in Watertown. *Courtesy of the Watertown Daily Times.*

noon at the New York Central Railroad Depot behind the Hotel Woodruff, Munroe met a friend, Clarence Johnson, who suggested taking in a matinée. Munroe passed on the idea, deciding instead on an evening show.

Munroe, or Charlie, as his friends called him, wasn't one to join in games with the younger neighbors, but on this day, he made an exception. In the Workmans' backyard, some neighborhood children gathered for a game of croquet. There was Olin Brown, ten, of 410 Dimmick Street, and his fourteen-year-old uncle from Pulaski, Donald Horton. Frances Wylie, fourteen, of 328 TenEyck Street, also joined in. Anson and Edna Workman came out to play, and so did Sarah Barden, ten, of 415 Dimmick Street.

Others also wanted to participate, but the gathering was either getting too big or the joiners were getting too young. Mabel Jones, Vivian's seven-year-old sister, was asked to leave, so she went home to 341 Mullin Street, where her mother made her lunch.

Munroe then unceremoniously told two other seven-year-old neighbors, Carl F. Brady and his buddy Frederick R. Love, to leave, according to Eleanor Love Ebbighausen of 430 Dimmick Street, who years later would hear her father tell how he had escaped an early death.

While the Brady and Love boys crossed the street, Harriette B. Semper looked out her kitchen window at 429 Dimmick Street.

"A moment before the blast came, I saw Salisbury mount the steps" to the veranda, Mrs. Semper told a reporter. "The last I saw of him, he was brushing his hair back from his forehead with both hands."

She did not notice him holding a croquet mallet, although Mr. Love would always repeat that Munroe had wielded a mallet against him, according to Mrs. Ebbighausen.

"I looked down for a second and as I was doing so the explosion came," Mrs. Semper said. "I looked out but could see nothing but a cloud of smoke and dust rising skyward, and it poured into my kitchen."

A Watertown lawyer, Charles A. Phelps, was driving on TenEyck Street and happened to check his watch. It was 2:53 p.m. when he heard the blast. He looked up and saw a blackish-blue cloud.

The windows of houses in a two-block radius were smashed by the concussion. All of the windows were shattered in Mullin Street School, kitty-corner and about one hundred yards to the north of the backyard where the explosion occurred.

An area of about one hundred yards in diameter was shrouded in deep black. Roofs of a number of buildings near the scene were torn by pieces of the shell. A small piece of shell was propelled through the walls of a garage twenty-five feet away and was found embedded in the side of a garage about seventy-five feet from the scene.

The lid of a garbage can that had been on the Workman veranda whirled forty feet before coming to a landing. A tire was blown to bits, its pieces showering Mullin Street School and several houses. Cherry and apple trees at the rear of the Workman house were destroyed.

The stone block construction of the house itself preserved the structure for future occupancy. But on both levels, plaster walls and ceilings collapsed, particularly at the rear, and doors and windows were blown in. Both sections "presented a scene of wreckage, beds being plaster-covered and bath tubs being filled with debris," the *Times* reported.

And there was the carnage. Witnesses estimated that children's bodies were catapulted fifty feet into the air.

Leon P. LaRock of 451 Dimmick Street and Claude Solar of 509 Solar Street were building a house at 419 Dimmick Street. They immediately

Munroe Salisbury was sixteen when he lost his life.

went to the site, where they found dead children, their bodies "terribly mangled, in some instances the heads and limbs [having been] blown off," the *Times* reported.

"I saw Mr. Workman looking for his boy," Mr. LaRock said at an inquest. "I showed him where he was and he said, 'That's not my boy.' He went away a bit, then came back and said, 'My God, it is.'"

He fainted. When he was revived, Mr. Workman was told that his daughter was also dead. "For two hours afterwards the man was prostrated," the *Times* reported.

Mr. Solar saw Fannie H. Wylie approaching. The widow of thirteen years was raising three daughters.

"I stopped her as I did not think it a fit thing for her to see her daughter in the condition that she was," Mr. Solar said.

Jessie Salisbury abandoned her upper apartment, which was suddenly devastated by flying glass and plaster. She ran into the road, screaming to the neighborhood's resident nurse, Anna O'Hara of 430 Dimmick Street, to come to the assistance of her son.

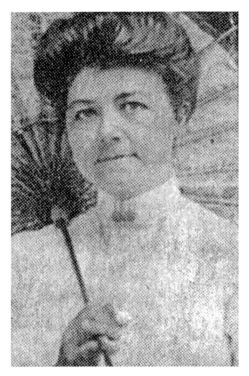

Jessie, the mother of Munroe.

Mrs. O'Hara, joined by her sister, Edith Love, ran across the street while two astonished boys, Carl Brady and Fred Love, watched from the Love-O'Hara driveway.

Strangely enough, the one child who was closest to the point of the explosion was still breathing. Munroe Salisbury was found gasping for breath while partially buried under some heavy blocks, near the Workman porch. His legs were torn off above the knees.

Edwin R. Greene of 403 Coffeen Street and W.A. Knapp, a YMCA resident, had been painting at 335 Mullin Street before the explosion and were the first to reach the boy. They removed the debris while Mrs. O'Hara tended to the teenager. He died in an ambulance en route to the hospital.

The two sisters retreated to their house, gathered blankets and sheets and then joined the house builders, who had collected their building paper, in the sad project of covering scattered remains.

District Attorney Wilcox was also among the first on the scene. Having just returned from a short honeymoon—he had married Addie Secor just four days earlier—Mr. Wilcox was near a garage about three hundred feet away when the blast had silenced the children's voices.

Moments later, fire chief William E. Gaffney, police chief Edward J. Singleton, detective Captain Alfred S. Wood and a squad of officers arrived to begin an investigation. Once it was learned that an artillery shell had been stored on the porch, Lieutenant White and Captain G.H. Schumacher, construction quartermaster at Madison Barracks, assisted investigators with their artillery expertise.

Mr. Wilcox instructed two doctors, Maurice D. Barnette and Harlow G. Farmer, to examine bodies for identification and to prepare reports for the inquest.

Word spread quickly, and it was not long before hundreds of people crowded around police lines. Only relatives of the victims, officials, those aiding in the work, press photographers and reporters were allowed to cross security lines.

A woman's phone call had alerted the *Times*. Three men were sent to the scene in taxicabs, while others went to the city's hospitals. The reporters telephoned their reports to the *Times*'s newsroom, where a story was written for an edition that hit the streets by 4:00 p.m.

Meanwhile, there was talk about those upon whom fortune had smiled. The three seven-year-olds could be grateful that they had been "victims" of age discrimination.

Lance Massey, twelve, son of Mr. and Mrs. Walter Massey of 412 West TenEyck Street, escaped death by a matter of minutes. He was just about to leave home to join the others in the Workman yard when the shell exploded.

Kenneth S. Barden, fourteen, would have died with his sister had he not grabbed the opportunity to earn some money as a golf caddy.

And there was the infant son of Grace Brown who was not put down for his nap that afternoon. Mrs. Brown, Sarah Barden's aunt, lived in Sarah's home. A piece of the shell passed through a bedroom window of the Barden house, ripped through the baby's unoccupied bed and lodged in a wall.

Several people were injured by flying stones. Widow Jane Judd, nearly a quarter mile away at 427 Cross Street, was standing in her yard when a rock struck her right hand.

Chief Singleton, determined to avoid similar calamities in the future, took action that would land him in hot water. Any such war or Pine Camp souvenirs should be immediately surrendered for disposal, the police chief announced. Failure to do so, he promised, could bring criminal prosecution.

His means of disposal: throw them in the Black River.

The outcry in protest was loud and swift, from citizens and paper mills alike.

Edith Love and her sister, nurse Anna O'Hara, rushed to the scene of the explosion. *Courtesy of Eleanor Love Ebbinghausen, Watertown, New York.*

"The public is right in condemning the destruction of artillery shells by throwing them into Black River," the *Times* editorialized. "As long as they are unexploded they are a source of danger and always will be. To throw them into the river, especially within the city limits, is dangerous."

In just three days—before the chief admitted that he was wrong—ten shells were committed to the river. But after his change of mind, the chief made another incredible decision. Until they could be destroyed by the military, all surrendered artillery shells were to be stockpiled at the police department in city hall on Court Street. About thirty such missiles were handed over to police.

"That Watertown has not had more disasters is a surprise to me," said Fanwood Goldsworthy, member of an ammunition division from New Jersey. "There is enough dynamite, TNT, powder and other explosives there to blow the city off the map."

The New Jersey unit arrived one week after the killer explosion, collected the shells, which were packed in sand, and trucked them to Pine Camp, where, one by one, they were detonated.

The shell that snuffed out eight young lives was a 155mm that had been fired in June 1921 during training by the 106th Field Artillery of the New York National Guard, Buffalo, Mr. Wilcox determined in the inquest.

The 106th, while not guilty of any criminal intent or act of criminal negligence, are subject to criticism for the manner in which they left said shells scattered about the firing area and their negligence in not properly policing in a military sense the field of fire.

Major General William J. Snow, chief of the army field artillery, responded. "Even the most careful search over a field…frequently fails to locate all unexploded fired projectiles," he wrote. The general said that the shells become buried in the ground, and to find them "is somewhat like hunting for a needle in a haystack." They eventually become exposed by rainfall or the seasonal changes in foliage, he added.

Mr. Wilcox was unable to determine what caused the Dimmick Street explosion. "The shell exploded by reason of being hit or jarred, or in some manner detonated, but how or by whom the evidence does not disclose," he said.

It had been standing for several months, subject to seasonal temperature changes, "and had been played upon by the sun's rays from early in the morning until after 1:00 p.m., through the hot days of June and for part of July," he said.

The priming cap was still intact enough to detonate the shell, Mr. Wilcox said, "and in a heated condition was very sensitive to a slight blow or jar and might have been detonated from a number of causes."

Noting that it had been very warm for several days, Mr. Wilcox said that temperatures at 1:00 p.m. on July 12 "in the shade" in sections of the city stood at eighty-six degrees. But behind the Workman house, "on that platform where there was no breeze and with the sun shining on the cement building and platform and playing on this shell, in all likelihood the heat was raised upon it to a much higher degree."

He figured that the fulminate of mercury in the priming cap had become superheated to such an extent that it reached an exploding point.

There was no testimony to say that Munroe Salisbury had set off the explosion, and Mr. Wilcox doubted that he had, as otherwise the boy's injuries "would have been more dramatic."

But in the nearly ten minutes that the teen survived, Mrs. O'Hara said in later years that she heard him gasp an admission that he struck the shell with a mallet, according to her grandniece, Mrs. Ebbighausen.

In an editorial, the *Times* asked that the public direct "no criticism or harshness" toward Mr. Workman for bringing the shell home. "There is no doubt that other homes of the city have similar shells, loaded and as dangerous."

Mr. and Mrs. Workman lost their only children in the explosion. Despite the tragedy, they never moved from Dimmick Street, although Mrs. Workman spent the last ten months of her life in a nursing home. She died in September 1954 at age seventy-six. Mr. Workman was seventy-nine when he died in March 1953.

With the deaths of Olin Brown and Donald Horton, Harriett L. Brown lost both a son and a brother. She had also lost another brother, Walter Horton, to the influenza epidemic of 1918.

Of the children who survived that day, one would die two decades later in an ironic twist of fate. Lieutenant Commander Lance Massey, age thirty-two, was killed in the Battle of Midway in June 1942. He was in charge of a torpedo squadron. A destroyer named for him was launched in August 1944. It was mothballed early in 1970.

Times *librarian Esther Daniels assisted with research for this column.*

A DEADLY YEAR
1918

After taking their marital vows at Watertown's Holy Family Church, James and Margaret McEvoy set out on a honeymoon trip that they could not complete. A week after Mr. McEvoy had joyfully taken his thirty-four-year-old bride, he was in mourning, preparing to bury her.

In Ogdensburg, Mrs. Henry Myers, twenty-eight, became ill and then died a day after she delivered stillborn twin boys. Jane Piddock of Adams was summoned by the Red Cross to help out at a Syracuse hospital. After two weeks on the job, her first call to duty for the Red Cross, the twenty-five-year-old nurse was dead.

Bringing his blessings to mounting numbers of ill people, a parish priest became ill. At thirty-four, the Reverend James Frances Haffey of St. Patrick's Church in Watertown was taken for his eternal reward.

"He died doing his duty," said his pastor, the Reverend Joseph L. Cole.

Northern New Yorkers were taking their places among the many people around the world who were falling victim to an epidemic. People were getting sick in droves, and many of them were dying. Often, the cause of death was listed as "pneumonia following an attack of Spanish influenza."

The killer flu, which had already cast its shadow across Europe, first showed its ugly face in the United States in March 1918 at an army post in Kansas, according to a PBS *American Experience* documentary. Seven months later, the nation was experiencing its deadliest month ever, with 195,000 deaths. That same month of October proved the hardest for residents of Watertown and nearby communities.

San Francisco, Philadelphia and Boston were already in the throes of the disease when, late in September, doctors in Watertown acknowledged

that "several hundred cases of severe colds" were being treated. "In many cases the colds are so severe that the victims believe that they have Spanish influenza," the *Watertown Daily Times* reported.

Stories appeared in newsprint about Jefferson County natives falling victim in Syracuse and elsewhere, but only one case of this flu bug had been confirmed in the region, in a military man at home on leave from Camp Dix, New Jersey. Then came news of the apparent first victim: "Man Dies Here of Influenza."

The *Times* obituary on September 30, 1918, announced that "Stephen H. Monroe of 602 Water St., aged 31 years, died early this morning at St. Joachim's Hospital of meningitis following Spanish influenza."

The account continued, "It is not known how the communication [of his disease] came about."

Headlines in the early days of October made it clear that this thing had really hit the area:

"Adams Nurse Martyr to Duty," said the October 1 announcement about Miss Piddock.
"Over 400 Influenza Cases about West Carthage."
"Over 200 Deaths in Oswego."
"Several Cases at Plessis."
"First Death at Norwood."
"30 Cases at Philadelphia, N.Y."
"Bride of Three Months Is Dead," read the headline for Ruth Cain Hendricks, another nurse and the twenty-one-year-old wife of future Jefferson County judge T. Arthur Hendricks.
"No Cause for Undue Alarm."

The latter headline that appeared in the *Times* on October 3, 1918, reflects an official's attempt to curtail panic.

Percy H. Willmott, president of the city's board of health, was not denying that an epidemic had indeed hit the area. Instead, he was addressing the shortage of nurses to deal with the situation.

"The nurse problem is one of the most difficult to face as there is a dearth of trained nurses," Mr. Willmott said. He announced that a registry of nurses was being devised to enable doctors to enlist assistance.

But he also tried to calm a worried public:

There is no crisis and the public need not be unduly alarmed. We need the cooperation of everyone to prevent a serious epidemic such as has prevailed

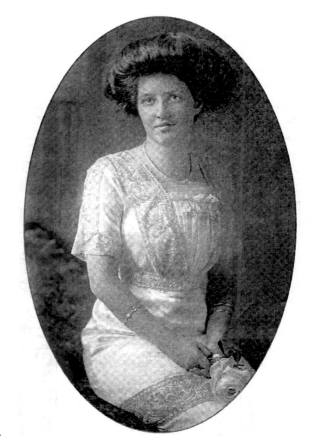

Katharine Hungerford Will, descendant of early Watertown settlers, was among 230 people who died in Watertown in October 1918 as a result of the flu epidemic. *Courtesy of the Jefferson County Historical Society.*

in some cities. The public can cooperate by following advice issued by the health officer from time to time and particularly to seek medical attention upon the first symptoms of the disease.

No time was wasted for a show of just how bad the nursing crisis had become. Early the next morning, Charles H. Dayton, sixteen, died at Bide-A-Wee Hospital at 1021 Bradley Street, a facility that had opened in 1916 with funding from Emma Flower Taylor for a thirty-year run as a center for treatment of contagious diseases. It was reported that the boy was at the hospital for more than twenty-four hours without being attended by a nurse.

The teen's death raised another concern. He had worked the prior three months at New York Air Brake Co., one of the city's major employers. On the same day of the youth's death, five cases of influenza were reported among the factory's forty-nine hundred workers.

Five days later, about fourteen hundred employees of New York Air Brake Co. were home sick. That was sufficient to interfere with the company's wartime munitions production, an official acknowledged.

The war industry had brought numerous job seekers into Watertown, creating overcrowded housing conditions, and that made the city particularly vulnerable to the epidemic, it was reported. And the bug was taking full advantage. Just nine days after that first flu-related death, doctors reported 2,090 cases.

Drastic action was needed, and Mr. Willmott responded. The city's health board declared a ban against public assemblages, and that included public funerals. "Pool Rooms Are Included," a headline warned. So, too, were theatres and motion picture houses, dance halls, gyms, swimming pools and churches.

"We must stop this promiscuous assembling," said Dr. Joseph D. Olin, a city health commissioner.

We must keep everyone who has the suspicion of a cold at home…I don't know how we are properly to care for those who are sick now. We're going to have to triple the number of cases and anything that we can do to stop one case must be done.

Mayor Isaac R. Breen wanted to close most stores, too, all but the pharmacies and food stores. But the board of health suggested that that "would be going too far," overruling the mayor.

Any homes occupied by flu sufferers were to be placarded with special cards to keep away the unwary.

Mr. Willmott also recruited three organizations to establish temporary emergency hospitals in their clubhouses: the Elks Club, the Knights of Columbus and the Masonic Temple. With help from his wife, Margaret, who was president of the Visiting Nurse Association, he was able to import a small number of nurses for the impromptu hospitals.

At a time when there was a great demand for nurses everywhere, this was no small accomplishment. In Carthage, for instance, the emergency hospital was said to be "taxed to the limit" with twenty-one patients. The situation was deemed "critical and there is a dire need for volunteers," the *Times* reported.

Meanwhile, a nurse died at the city hospital (today's Samaritan Medical Center) on October 11. Iva Fry, twenty-four, was reported to be the first local nurse to die as a result of contracting the disease from the epidemic patients she had assisted.

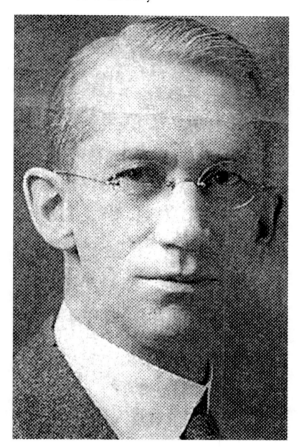

Percy H. Willmott. *Courtesy of the Jefferson County Historical Society.*

Responding to the plight of their fellow medical professionals, some of the city's dentists took on new roles. Drs. Guy H. Cole, David Fawdrey, Louis Stabinsky, Harry C. Howell and William B. Tanzer stopped at houses where handkerchiefs hung from windows, the designated signal that help was needed. They administered first aid and determined if a physician should be summoned.

Two other dentists, Charles S. Fowler and Edwin I. Harrington, served as orderlies at the Masonic Temple. The dentists were critical of one of their colleagues, who insisted on receiving the same fees paid to physicians. He was told that his help was not needed.

Perl W. Devendorf, who operated a Ford dealership on Arsenal Street, provided a Ford chassis for an ambulance, which he had fitted out at his own expense. He also served as the driver and had three men assisting him. They wore regulation masks over their noses and mouths.

The calls were many, but sometimes the ambulance could not transport. The various hospital facilities filled fast, prompting Dr. Andrew H. Allen, health officer, to advise physicians to avoid sending patients to the hospitals except those people who would likely die without proper attention.

Stories of human suffering emerged. A young Italian boy, in a fit of delirium, jumped from a third-story window of one of the emergency hospitals. A nurse had just taken his temperature and left the room. He climbed out of bed, ran to the window, jumped out and landed on a shed. He then rolled to the ground, breaking some ribs. His condition was said not to be critical.

Emergency volunteers told of entering an unheated house on the city's north side to find fourteen people sick in beds that lacked linens. The floors were uncarpeted.

In another unheated home on Moulton Street, a mother and four of her six children were sick. A small girl in the house was delirious.

On Emerson Street, a grandfather was fighting early symptoms while trying to care for his ill wife, daughter and son-in-law, as well as the younger couple's baby.

All five members of a Jackman Street family were found sick in their beds, volunteers reported.

Ida Jessmore, fifty-three, of 745 Fairview Street, died in her home when she was unable to get a physician's help. The doctors were too busy to attend to everyone. Her husband, George, was also ill.

Death announcements began monopolizing the pages of newspapers. Between the afternoons of October 19 and 21, officials counted twenty-eight deaths in the city.

Among the victims, not necessarily in that weekend, were Mrs. Katharine Hungerford Will, twenty-six, a descendant of early Watertown settlers and the mother of two-year- and four-month-old daughters; Dennis J. Brennan, "a well-known young lawyer" in Watertown; and Alice D. Cooper, thirty-two, mother of seventeen-month-old twin girls.

Funeral parlors were overworked. One undertaker had twenty-four funerals in two days. Since gravediggers were being overwhelmed and immediate burial was an objective, prisoners were dispatched from Jefferson County Jail to wield shovels in various cemeteries.

The power of the epidemic fortunately seemed to erode as quickly as it had flexed. By the end of that sad October, the situation had calmed. On Sunday, November 3, the ban against public assemblage was removed.

"This order permits the churches to hold the regular Sunday services and affords the education department opportunity to prepare for the opening of

Emma Flower Taylor.
*Courtesy of the Jefferson
County Historical Society.*

schools Monday," the *Times* reported. However, certain restrictions would remain in place, the November 1 notice added.

October's tally sheet showed 281 deaths in Watertown, 230 of them because of the flu. There were 283 burials during the month, the majority of which took place in North Watertown and Glenwood cemeteries.

The city's cost from the epidemic was $6,000, but the wealthy Emma Flower Taylor stepped forward to foot the bill. She more than doubled that amount, giving the health board cash to deal with whatever related burdens might occur.

Public morale probably took a jolt on December 9, when it was reported that six new cases of influenza had appeared in the city. Four were in the family of Mr. and Mrs. Samuel B. Wardwell of 156 Clinton Street.

Dr. Allen offered reassurance that the new cases did not indicate a recurrence of the epidemic, and four days later, health officials did more cheerleading, saying that the end of the epidemic was imminent.

"A close account is being kept of all cases but none has developed in weeks that would indicate that the disease is reappearing in its virulent form," they said.

Time proved them to be correct.

At the close of the year, a team of nurses visited about 26,000 of Watertown's estimated population of 35,000 to determine the impact of the epidemic. They found that 6,477 people in 2,738 families, about 25 percent of the population, had been afflicted. Statistically, if the entire population had been queried, it can be estimated that Watertown may have had 8,700 flu sufferers in little more than a month.

"We continually find cases of influenza in Watertown," the nurse spokeswoman, Josephine Durkee, said. "But most of them are mild cases, and there is no epidemic here at the present time. It is what we call an endemic rather than an epidemic."

Jefferson County was to suffer still another loss, a nurse. Early on January 6, 1919, Alice Audina O'Connor, nineteen, of the town of Brownville, died at the city hospital of pneumonia following influenza. She was a nurse in training at the hospital, having entered the class in July. She was ill for less than a week with influenza, which developed into pneumonia.

At the height of the epidemic in October, an announcement was made that demand had exhausted existing supplies of a popular remedy, Vicks VapoRub. Druggists were advised to order in small lots.

No fewer than twenty-seven physicians in Watertown labored, probably beyond the point of exhaustion, in treating the many sufferers. In addition to Drs. Allen and Olin were Drs. Charles M. Bibbins, Murray M. Adams, John A. Barnette, William C. Couch, Andrew J. Dick, Orlando C. Eastman, J. Mortimer Crawe, Grosvenor S. Farmer, William J. Flint, Isadore L. Green, Henry A. Hoyt, Ambrose E. Ilett, William J. Kellow, Charles C. Kimball, Elgin R. McCreary, Wilmer D. Pinsoneault, Fred B. Smith, Herbert L. Smith, James M. Smith, Harold B. Stowell, Leo J. Corrigan, Gilbert B. Gregor, Florence Meader, Charles E. Pierce and Harry A. Pawling.

The nation lost 500,000 lives to the flu. Globally, the toll was 20 million people.

Times *librarian Patricia E. Delaney conducted research for this column.*

THE COURT STREET BRIDGE CATASTROPHE

A Catastrophe!" the headline screamed. Had the stunt man failed in his death-defying performance?

No. But his presence that day, May 30, 1898, helped cause a near disaster on the banks of the Black River in Watertown. A large crowd, estimated at more than one thousand people, had gathered around the iron Court Street Bridge to watch stuntman James A. Brady take his promised dive into the chilly and turbulent Black River. Instead of being the main attraction, Mr. Brady became a spectator.

A handful of people tumbled from a collapsing porch into a rock hole overlooking the river. Perhaps miraculously, no lives were lost. But the event was surely never forgotten by victims and onlookers alike. And by some embarrassed city leaders, too.

The show was to begin at 3:30 p.m. Mr. Brady, from New York City, had advertised that he would jump from the very top of the span, which fourteen years earlier had replaced a wooden covered bridge. Folks were standing high and low, on rooftops and sidewalks, finding whatever vantage point possible to view this daredevil stunt.

It was, of course, no free show. Mr. Brady was an entertainer. It was reported that he was a former member of the Crane Dramatic Co., which, perhaps by no coincidence, had just a week earlier staged daily comedy performances in the City Opera House. Mr. Brady and his assistants worked their way through the crowd, hats in hand, collecting donations big and small.

Finally, the moment of the attraction was approaching. The exhibitionist climbed up the iron framework of his "stage" and began a speech, exhorting the curious watchers to be generous in their support.

A Watertown police officer assigned to crowd control, Charles B. McMullen, was meanwhile trying to keep the streets open for traffic. The officer, who had joined the police force only about a month earlier, walked over to a building on the north side of the river, just east of the bridge, to dispatch spectators off a veranda.

His warnings were not heeded. After about five minutes, "as many… spectators as could do so crowded together on the wooded steps" of the old frame building, the *Watertown Daily Times* reported. "Their weight was more than the timbers of the old structure, weakened by time and decay, could support."

Boards supporting the steps gave way. The platform collapsed.

At one end of the veranda, the land surface was only about six feet below. But at the far end, the drop was twenty-four feet.

"The entire number of people" on the veranda tumbled with the shattering boards, bounding off rock edges and looking precariously down at the swift-flowing river. Several of the victims became "piled in a struggling heap at the bottom" of the chasm, the *Times* account continued. The stuntman's speech was now suddenly being drowned out by shrieks, screams, shouts and cries.

"A scene of wild disorder at once ensued," the *Times* reported. People who had anticipated watching a single man dive into the river were now looking "with wide-eyed open-mouthed horror" as the sufferers below "struggled and trampled upon each other in their efforts to get out" of their trap.

Perhaps twenty-five or thirty were able to climb out, with only some scratches and bruises to show for their trouble. There were fifteen initially listed as injured, although that number would swell two months later when legal claims were filed. Some lay quiet or unconscious, the paper said, and one boy was feared dead.

Observers lurched forward to see what had happened. With the first rush of the crowd, a small girl wearing a bright red dress who was standing on the sidewalk was shoved over the bank. She fell about thirty feet but had only minor injuries, it was reported.

A six-year-old boy was also pushed over. His fall was only about five feet, but he dangled precariously from the edge of the rocks.

Officer McMullen at once forced his way through the crowd and pushed people back to get them out of harm's way. "In doing so he narrowly escaped being shoved over himself and rescued two or three men who came near taking the plunge," the *Times* claimed.

The Court Street Bridge from which James A. Brady was to do his stunt. The building to the right is believed to be the site where a porch collapsed beneath the weight of an assembled crowd. *Courtesy of the City of Watertown historian.*

"The efforts of a few strong, cool-headed men prevented a greater number from joining the screaming pile of victims," the account continued. Particularly recognized were four men—Phin Thomas, Jim Landon, George "Taffy" Morrison and Mike "Greasy" Kelly—who "worked like Trojans in the labor of rescue."

More policemen arrived. There was two-year veteran Alfred S. Wood, along with a couple of rookies, Luke A. Burns and John Gilligan, who was destined to become police chief thirty-seven years later.

"Policemen Gilligan and Burns, with coats off and shirt sleeves rolled up, descended to the hole and set about the work of rescue," the news report said. As Officer Burns climbed down, his first attention was drawn to the boy clinging to rocks. Burns reached down, "caught the boy by the hair and lifted him up to McMullen above."

Several doctors, including Charles B. Flint, Herbert H. Smith, Wallace N. Brown, M. Lee Smith, James D. Spencer, Andrew J. Dick, J. Monroe Smith and J. Mortimer Crawe Jr., left their offices to attend to the injured.

One by one, victims were brought up to street level. Among the rescued were Mrs. Philip Couch of Curtis Street and her three children. Her three-year-old son was early considered to be in grave condition with a concussion. He was unconscious for several hours, but a day later it was reported that he had rallied, and "his ultimate recovery is practically assured."

Julia Fitzgerald, a domestic, had head and back injuries and was taken to Sisters Hospital on Benedict Street. Removed to City Hospital (forerunner of Samaritan Medical Center) was Benjamin W. Peckham of Watson, who suffered two broken ribs and head cuts.

Others were taken to their homes: John Leggett of Moulton Street with broken ribs; Nellie Lyon of Meadow Street with head cuts; Mr. and Mrs. John Babcock of Dorsey Street with bad bruises; Mrs. Fred Gould and Mrs. W. Swartz, both of LeRay Street; Michael J. Skiffington of Bradley Street; Gertrude Almond of Franklin Street; and the twelve-year-old daughter of Edward Mullin of Maple Street.

Lest we forget, a dog was also rescued but had to wait until last. "The dog wore a worried look but happily was uninjured," *Times* readers were cheerfully informed. "When set safely on the walk he made a yellow streak of himself in his haste to leave the scene."

In the aftermath, a number of people who had minded Officer McMullen approached him with thanks "for having saved them from themselves," the *Times* said.

Meanwhile, the entertainer showed himself to be "the cheapest kind of sport," the newspaper reported. As far as Mr. Brady was concerned, the show must go on. As far as police and Mayor James B. Wise were concerned, it must not. At 4:30 p.m., an hour after the great spill, Mr. Brady was told to forget about it.

"Brady was money ahead by the transaction, as a considerable sum was collected by some helpers and himself previous to the exhibit," the *Times* said. "The police were looking after Brady very closely" that evening "as they noticed he was looking for trouble and was apt to find it. He was interfering with pedestrians and chased one man into a saloon."

City hall officials were asked why this spectacle—the planned jump, that is—was allowed to take place. Was it approved? Mayor Wise confirmed that a license had been issued to Mr. Brady.

Claims against the city followed, to the tune of nearly $78,000. Documents filed in July 1898 cited Watertown with liability for injuries "due to the fact that said sidewalk, steps and platform were out of repair, unsafe and dangerous by reason of the decay and rottenness of the supports."

The largest claim was from the Couch (originally Kausch) family, who wanted $27,000 for injuries and "loss of services" of Mrs. Couch and sons Philip Jr. and Carl.

John Babcock sought $7,000 for his personal injuries, expenses and "loss of services" of his wife, Elizabeth. Mrs. Babcock filed for an additional $5,000.

Other claims were $10,000 by Mrs. Lyon, $8,000 by Mr. Peckham and $2,500 by Mr. Skiffington. Alfred L. Gould asked for $2,000, while Gertrude Almond would be satisfied if she could collect $200.

And then there were the claims from previously unreported injuries. Those included $7,500 by James Belcher; $2,000 by Mercy A. Rogers of Stone Mills; $1,000 by Gertrude Griffin and $200 by her father, John, due to lost services; $1,000 by Frank Bristow; $2,000 by Matilda Gegoux; and $2,500 by Emory Surprise.

The cases dragged into the next century, finally being resolved in June 1906, following the death of Philip Couch Sr. It appears that none of the claimants came out very happy. Documents found in the city clerk's office indicate that the total payout was $11,750.

Who were these people? What did they do in life? I was able to find reference to a few of them. Alfred Gould, who was seventy when he died in 1928, was a charter member of the North Side Improvement League. He was a commercial traveler for International Harvester Co. before becoming a deputy city assessor in 1925. James and Esther Belcher, parents of nine, were natives of England and crossed the Atlantic in 1876, during their seventeenth year of marriage. He worked with the city department of public works.

One of Mr. Belcher's co-workers was John W. Babcock, a native of Newburg, Ontario. Mr. Babcock was survived by his wife, the former Libbie Mason of Gouverneur, when he died at age seventy in 1931.

Michael Skiffington was a bricklayer, and Edward Mullin was a teamster.

The iron bridge on which James Brady stood in 1898 was demolished and spilled into the river to make room for a two-level, mostly concrete span erected in 1921. The latter bridge was closed in 1993 for yet another span that stands today.

Watertown city clerk Donna Dutton contributed to this story, and Times *librarian Esther Daniels assisted with research.*

THE SMILING COP

There was little to smile about in the 1930s, the era of the Great Depression. But for a passing moment, a Watertown cop helped people put their miseries in the background.

Standing at the American Corner, where Court and Arsenal Streets split off from Public Square, Herman C. Trumble greeted all who approached with a courteous salute, a big smile and a friendly word or two.

He became so popular—not only about town but also beyond city and county boundaries—that his picture was in the paper just for being a guest speaker at a banquet in Sackets Harbor. There were other speakers at the October 1930 chamber of commerce affair, but only the happy face of Officer Trumble appeared in the paper.

He donated blood to a fellow officer's ailing wife, and again his picture appeared in the paper. Another officer, Clifford A. Damon, gave blood too, but no one saw his face in the *Watertown Daily Times*.

Even as Officer Trumble lay seriously ill in the hospital, people were endorsing him as Republican candidate for sheriff. And it was during this illness that people, despite being burdened by their own financial situations in the troubled economy of the day, scraped dollars together to help him meet expenses.

This is the story of the "smiling cop," as Mr. Trumble would be known well beyond his seven years on the police force.

Just like any other day of the year, the policeman was working his beat, directing traffic at the American Corner on December 30, 1931, and assuring safe crossing for pedestrians. Officer Trumble was likely still being his cordial self.

A traffic cop with an ever-present smile, Herman Trumble. *Courtesy of Mary Jo Roberge, Liverpool, New York.*

But he was not feeling well. As the mercury hovered just above twenty degrees, with sunset fast approaching, he was getting progressively worse. Finally, he was rushed home, only to be taken a short time later to the House of the Good Samaritan.

Less than two hours later, at about 6:00 p.m., the thirty-four-year-old cop was in surgery, under the skilled care of Dr. Frederic R. Calkins. He had a serious case of stomach ulcers.

Mr. Trumble had been wearing the city police uniform for about six years. One of ten children of Joseph N. and Emma B. Lester Trumble, he had served with the Marine Corps during the First World War, although his assignment was south of the Mason-Dixon line. Following his military duty, he went to work for H.H. Babcock Carriage Manufacturing Co. on Factory Street.

He married Katherine E. Cleary on February 4, 1920, and by the end of the year, the couple had a son, Joseph.

About five years later, Mr. Trumble decided to become a city cop. From then on, "this 'smiling cop' who has been performing his happy service among us here" was "held in high regard and indeed affection by the people of this town," said a *Times* editorial. "He has brightened the way for limitless numbers."

He had offered assistance to a fellow officer's wife just eight months before his own illness. Lena W. King, thirty, of 264 Seymour Street, wife of patrolman Evangelist J. King, was seriously ill in Mercy Hospital when blood donors were sought to help her. She eventually had surgery, recovered and lived to age eighty-four.

Now it was Officer Trumble who was being taken to the operating room. Dr. Calkins determined that an ulcer had perforated the stomach wall, necessitating emergency surgery.

The sixty-year-old physician was considered a north country pioneer in the field of surgery. "What separated him from the rest of his colleagues was his willingness to innovate," said a biography of Dr. Calkins in a February issue of the Samaritan Medical Center newsletter.

Dr. Calkins, who opened a general medical practice in Watertown in 1894, studied at the Mayo Brothers Clinic in Rochester, Minnesota, before becoming a surgeon in 1907. In the half century that followed, he estimated that he performed twenty-five thousand major operations.

A day after surgery, Officer Trumble was said to be "pretty good," but he was having difficulty with his lungs, suffering from bronchitis. There was danger of pneumonia developing.

Herman Trumble doing his thing. *Courtesy of Mary Jo Roberge, Liverpool, New York.*

Tales of "Times Gone By"

From that day on, the police department, the *Times*, the city manager's office and the hospital were reported to have received hundreds of calls inquiring about his condition. Police officers who went door to door taking a dog census reported that there was always an inquiry about Officer Trumble.

The *Times* maintained a regular update on his condition:

January 2, 1932—The officer was "much improved today" and "getting along all right." He was considered out of danger, although the possibility of pneumonia still persisted.

January 4—He was slightly improved and resting comfortably, with his lungs clearing up.

January 7—There was a setback today. He underwent a second operation for an obstruction of the intestines, which developed as the result of the original operation. While the operation was a satisfactory one, the police officer's condition was described as "fair." Dr. Calkins said he was still suffering from bronchitis but was not in immediate danger.

January 8—His condition was "slightly improved," and his wife spent the entire night near him. Many floral tributes had been received at the hospital for him.

January 13—"He was reported as improved today. It is believed now that he will recover unless something unexpected occurs. However, he must remain at the hospital for some time, and the aggregate expense of his illness will be large."

And the flowers kept coming every day, to such an extent that "there is no place for them in his room and they have been distributed around the hospital," the *Times* reported.

The *Times* announced that at the request of two close friends of Officer Trumble, the newspaper was sponsoring a fund drive to help him out.

"Friends say his recovery is being retarded by worry over his financial condition," a *Times* article reported. "He has no money to meet his hospital or physician's expenses, and this is continually on his mind."

The city was continuing to pay his wages, the paper said, "but this pay is only sufficient to support his family. He has had a number of obligations to meet of late and has no reserve to meet the heavy expenses which have piled up as a result of his illness."

One *Times* editorial added, "In reality now that he is in trouble there is a public obligation to see to it that he is relieved of the money strain."

The "smiling cop" directing traffic at the American Corner. *Courtesy of Mary Jo Roberge, Liverpool, New York.*

The two friends, stressing that money would do more good than flowers, each threw in $5 to kick off the campaign. The *Times* set a goal of $1,000. Within a week, nearly $550 was raised.

After eighteen days, the drive was concluded, with $1,011 in the till. Donations arrived from Detroit, Buffalo, New York City, New Jersey, Pennsylvania, Florida and communities throughout the north country. A man's two-dollar donation from Buffalo was accompanied by this note: "I figure it is at the rate of only one-thousandth of a cent for each smile Herman has given me."

Five people signed their donations as "from one who appreciates [or enjoys] a smile."

The *Times* printed the names of those givers who so desired. Among the 106 one-dollar donors were three-year-old Betty Jane and five-year-old Larry Woodcock.

At fifty-one businesses and organizations, the hat was passed among workers and members. "It is seldom that there has been such a response to any public appeal as that for the fund for Herman Trumble," the *Times* reported.

With this outpouring of support, some of the officer's friends decided to advocate for him as a Republican candidate for sheriff, even as he continued to recuperate in the hospital twenty-eight days after his initial surgery.

"Those who are putting forth his name express faith that he would make an excellent sheriff," the *Times* reported on January 26, 1932. "They say that his experience of several years as an officer on the Watertown police force

His police career behind him, Shell Station owner Trumble reviews unemployment insurance for employees with John Cowen of the state labor department. *Courtesy of the Watertown Daily Times.*

would be of immeasurable value in the conduct of the criminal work of the office."

He had not been mentioned previously as a candidate, the *Times* reported, but "the suggestion has been favorably received by many."

His sponsors believed that if nominated, Mr. Trumble would do well in the election "because of the extent to which he is known throughout the county and his general popularity," the article continued.

Whether by his choosing or that of someone else, Mr. Trumble did not run, and the man who carried the Republican banner, LeRoy S. Harrington, was elected.

When the phone rang at the 643 Mill Street home of Herman and Katherine Trumble on the afternoon of January 30, 1932, Herman

Herman C. Trumble was all smiles. *Courtesy of Mary Jo Roberge, Liverpool, New York.*

answered. He had just been discharged from the hospital earlier that day, and he told the caller—a *Times* reporter—that he was "feeling fine" and was able to walk around his home and on the street again. But four days later, he was back in the hospital, being observed for an intestinal ailment.

After returning home the next day, February 4, he was visited by a delegation consisting of *Times* editor and publisher Harold B. Johnson,

Tales of "Times Gone By"

Mayor John B. Harris, City Manager Paul B. Sutton, police chief Edward J. Singleton and *Times* city editor Harry F. Landon.

Handing Mr. Trumble a check for $1,011, Mr. Johnson said, "This is an indication of the esteem in which you are held by the people of Northern New York."

Knowing of the public's financial assistance was an important factor in his recovery, the officer said, expressing his gratitude.

Mr. Trumble was back on the job on May 2, but his happy face was no longer seen at the American Corner. The department bosses believed that his old job would be too strenuous for him. His new assignment was checking cars on Court Street.

On August 5, 1933, just fifteen months after his return to duty, Herman Trumble turned in his resignation. He was going into business with a partner, Frederick Gates. The following week, Gates and Trumble Shell Gas service station opened at 1544 State Street. It was a new career that would keep him occupied for most of the next two decades.

Eventually becoming sole owner of the business, Mr. Trumble teamed with Shell to open a new service station in May 1937 at 540 State Street, where the Trailways bus terminal now stands.

"Much money and thought were expended on the construction and design to make it the finest in Northern New York," a *Times* story announced. "Cars may be serviced efficiently and conveniently. The yard and pump islands are arranged so that four cars may be served at one time without inconveniencing either the motorists or the attendants."

Mr. Trumble and his employees "have been thoroughly schooled" for operation of new lubrication facilities fit for all types of automobiles and light trucks, the report continued. And of course, modern restrooms had been installed.

Health became a factor again in 1951, prompting Mr. Trumble to sell the business to Bert E. Mabe, but by 1956, he was back running the shop, now called Herm's. He was also making news again.

The *Times* lauded Mr. Trumble as the first small businessman in Watertown to provide unemployment insurance to his three workers under the extended-coverage provisions of the state unemployment law that had just gone into effect. To mark the occasion, a state labor department payroll examiner, John D. Cowen, delivered a poster for display at his business.

"I don't intend to lay off any of my workers and I hope I never have to," Mr. Trumble said. "But it's good to know that I can offer them the same unemployment insurance protection as the largest firm in the state."

He had three employees at the time: his son Joseph, Harry Oatman and Floyd Ruttan. Mr. Trumble retired late in the 1950s.

He was still remembered as the smiling cop when he died at age seventy-three on May 25, 1971, in the House of the Good Samaritan following a hospitalization of about six weeks.

Katherine died on March 19, 1974, at the age of seventy-nine.

Their son flew fifty-nine missions over Italy and the Balkans as a radio gunner aboard a B-25 bomber during World War II, earning two Bronze Stars and an Air Medal. Later a salesman for Burns Supply Inc., Joseph Trumble was eighty-five when he died on January 27, 2006. He and the former Lucy Frattali, who survives, were the parents of Mary Jo Trumble Roberge, now of Liverpool, and Katherine A. Trumble Sandy of Hanover, Virginia.

According to Jeffrey M. Garvey, director of library services at Samaritan Medical Center, Mr. Trumble's thirty-two-day hospital stay in a men's ward in 1931 and 1932 probably cost about $70.00—$2.15 per day—plus $40.00 for use of the operating room, $4.00 for medical supplies and some extra charges for radiographs, dressings and drugs.

I acknowledge Times *librarian Lisa Carr, Mary Jo Roberge and Jeffrey M. Garvey for their assistance with this story. Also, Timothy J. Abel, director of the Jefferson County Historical Society, assisted with a photo reproduction.*

ABOUT THE AUTHOR

D ave Shampine has been a reporter for the *Watertown Daily Times* for over three decades. Since 1998, he has been writing his history column "Times Gone By," which aims to blend historical fact and human interest to tell a compelling story. His awards include the Media Awards Certificate of Merit from the New York State Bar Association, the Local Reporting Award of Excellence from the New York Newspaper Publishers Association, a second-place award in spot news reporting from the New York State Associated Press Association, a Certificate of Appreciation from the New York State Department of Labor and a Communication Award from the Veterans of Foreign Wars, Ladies Auxiliary. Dave is also a member of the Jefferson County Historical Society and a contributing writer and copy editor for the society's "Bulletin." He is a graduate of Jefferson County Community College, Watertown, and of the State University of New York at Brockport. In 2007, he was presented a professional achievement award by the Jefferson Community College Alumni Association, which later placed him on its board of directors.

Visit us at
www.historypress.net